A homage to
Typography

Copyright 2009
INDEX BOOK, SL
Consell de Cent, 160 local 3
08015 Barcelona
T +34 93 454 5547
F +34 93 454 8438
ib@indexbook.com
www.indexbook.com

Author: Pedro Guitton
Design: Mito Design and Floor Koop
Cover: Floor Koop
Cover image: Alexander Egger
Digitization of some fonts on CD: Gaston Gabrielli and Floor Koop
The font copyrights belong to their designers

Proofreading: Silvia Guiu and Shawn Volesky

ISBN: 978-84-92643-07-3

Printing: Dami Editorial & Printing Services Co.Ltd.

A homage to
Typography

Directory

Introduction

In my opinion, typography is the very essence of graphic design. However, in my classes and the speeches I give throughout the world, students are constantly asking me what I mean by this.

When you create a typeface, you take a giant step towards your own style. You create personality. You give your projects that original touch. Typography brings an important and fundamental aspect of personality to communication. It is also the best way to get your design out in the world. Why should anyone become a designer if they can be a typographer? This is the question I frequently ask my students to get them to rethink the whole process. Since designers are constantly choosing fonts to include in their work, typographers have the potential to be part of a huge range of different projects.

Can you imagine how many brands in the world are using fonts like Fruitiger, Futura, Gill Sans, Bodoni Benguiat and others? Fonts are used no matter where you go—and not just by design agencies and type foundries. "Normal" people also select fonts when they want to present a project, write a letter or send a note to a relative or friend.

The main thing to keep in mind when developing a typeface is to create a different category. That will help ensure that your font is different and accepted in the market. If you can, add a bit of emotion, and don't forget that it must have retail value. These basic steps will help get your font accepted by type foundries (companies that distribute typefaces), which is a very nice place to start.

I would love to see your proud faces someday when you are walking along somewhere and come across your own typeface (after it was featured in this book).

Also, congratulations! You're getting your style out there!
Pedro Guitton

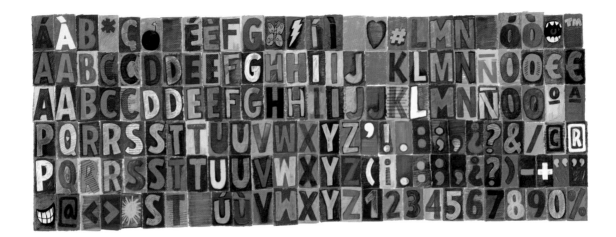

Concept

An illustrated alphabet commissioned by the Shakleton agency in Madrid for Orange's "40tv móvil" campaign. The font had to look like it was hand-drawn with markers and colored pencils, appear young and colorful, be usable in a variety of different media and allow for easy manual composition without significant kerning errors or repeat letters. This is why there are multiple versions of each letter. The font also contains a series of icons.

Contact info

Studio Copyright
Joel Lozano
www.studiocopyright.com
www.joellozano.com
Spain

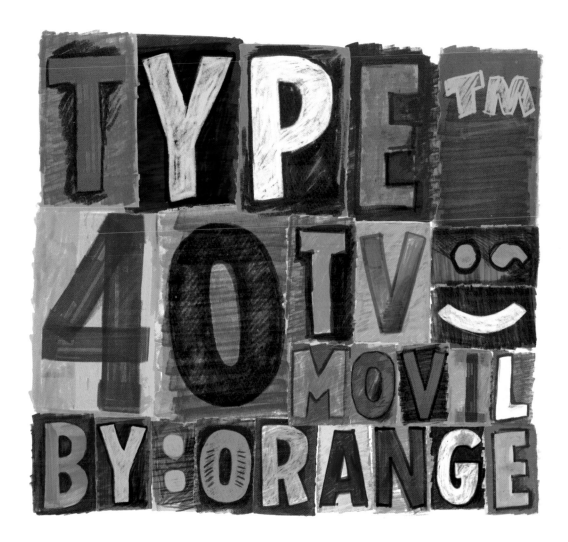

No pasa nada, tenemos...

El gran maestro de la costura:

Prueba del UCI Pro-tour:

Tu periódico:

Dio la vuelta al mundo:

Recinto Ferial transfronterizo:

Territorio histórico :

Famoso por sus sanjuanes:

Queso con denominación:

Festival de Jazz:

Auditorio:

Hipódromo:

Grupo Cooperativo de prestigio:

Saltadora de pértiga:

Universidad más antigua:

Golfista:

Escultura dedicada al viento:

Festival de música clásica:

Equipo de fútbol de 1ªdivisión:

Lluvia fina:

Famoso por sus carnavales:

Boxeador:

La oreja de...

Ciudad alemana hermanada:

Bertsolari:

Trazado ferroviario:

Pintor:

Concept

An advertising campaign from a Spanish daily newspaper with the theme "Gipuzkoa is like this".

Contact info

Dimensión Marketing Directo, S.A.
Iratxe Elso
ielso@dimensiondmd.com
www.dimensiondmd.com
Spain

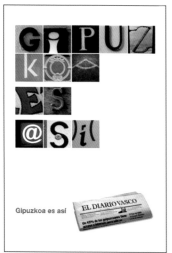

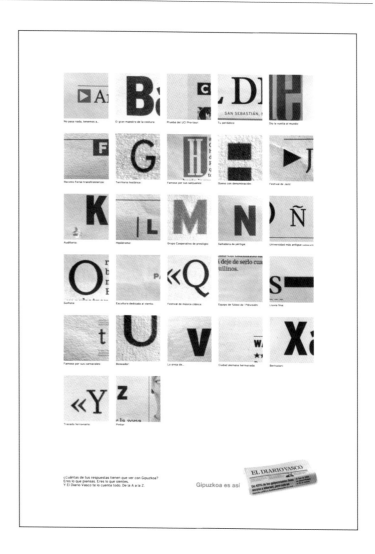

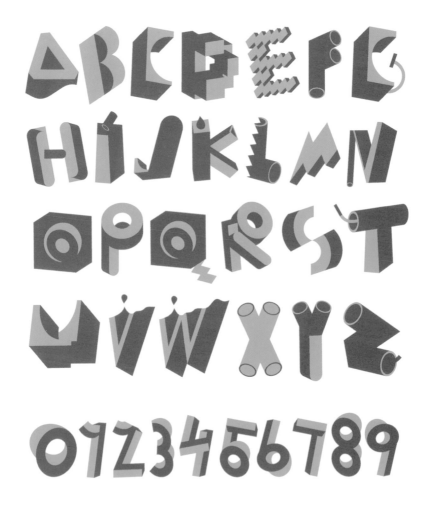

Concept

AC was used on a poster in Sweden for the band Animal Collective.

Contact info

BankerWessel - Jonas Banker
jonas@bankerwessel.com
www.bankerwessel.com
Sweden

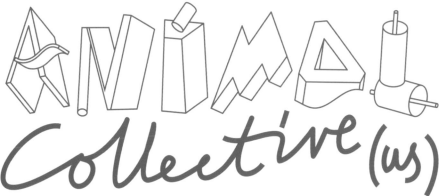

ARTVOD

medium

Aa Bb Cc Dd Ee Ff Gg
Hh Ii Jj Kk Ll Mm Nn
Oo Pp Rr Ss Tt Uu Vv
Ww Xx Yy Zz Šš Đđ
Ċċ Čč Žž ! ? , . – = []
+ : / \ @ 0123456789

Concept

This font was designed in 2007 for the "ARTVOD Museum of Digital Art" project and was inspired by digital media and their influence in everyday life. The project included an interactive presentation, posters, a book and packaging.

Contact info

Dusan Jelesijevic
dusan.jelesijevic@gmail.com
www.dusanjelesijevic.com
Serbia

ARTVOD

MUSEUM OF DIGITAL ART

UVOD

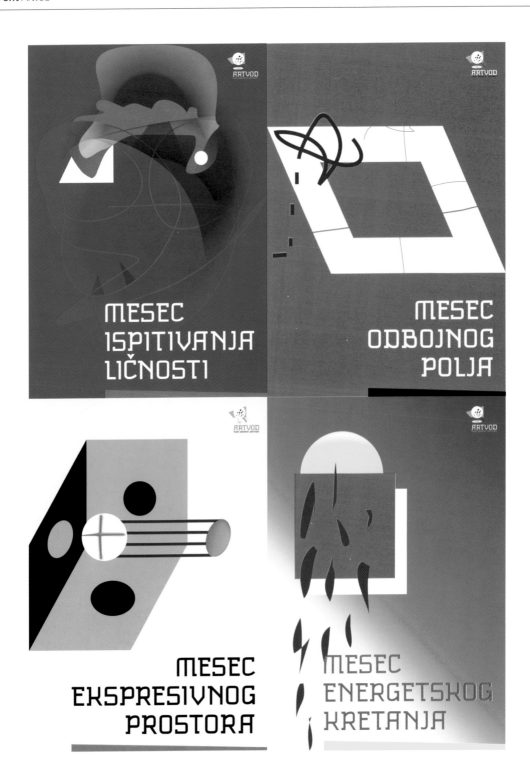

MESEC
BOJENOG
POLJA

MESEC
OCNE
DISFUNKCIJE

MESEC
DIGITALNOG
JEVANĐELJA

ARTVOD
MUZEJ DIGITALNE UMETNOSTI

Dušan Jelesijevic

V godina, 2007
Diplomski rad

CD sadrži:

Knjigu standarda *(PDF)*
Seriju plakata *(PDF)*
Font ARTVOD *(TTF)*
Prezentaciju fonta ARTVOD *(PDF)*
Interaktivnu prezentaciju *(SWF, EHE)*
Instalacione programe *(Flash Player, Opera)*

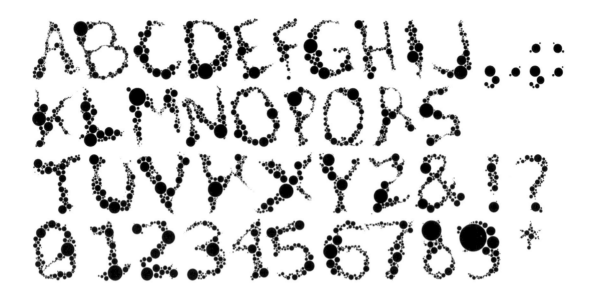

Concept

Asteroids Belts was created for use in headings, and the design is inspired by asteroids. It brings a futuristic look to design projects.

Contact info

Rodolfo Hans
rodolfohansss@msn.com
Brazil

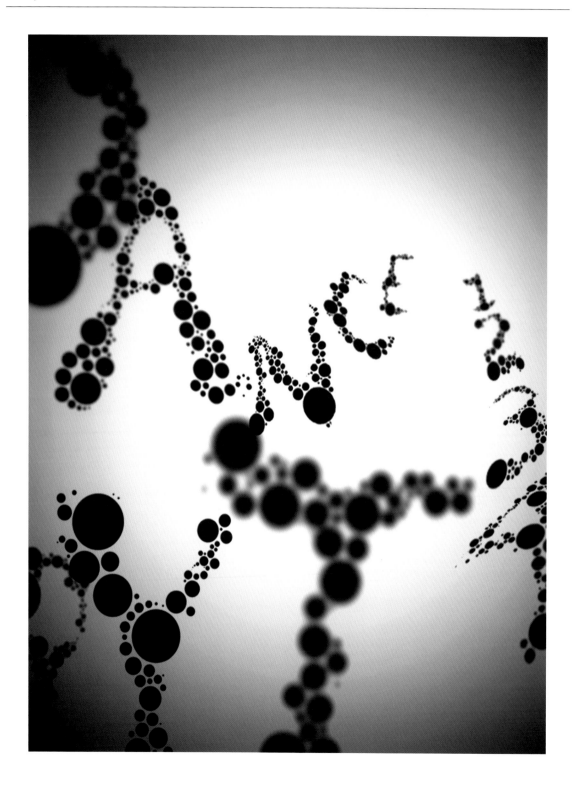

ABCDEFGHIJKLMN
OPQRSTUVWXYZ

abcdefghijklmnopq
rstuvwxyz.

0123456789

Concept

This font was based on Helvetica and was made using hair gel. The project was presented at Pecha Kucha in Amsterdam on December 25, 2008.

Helvetica is a trademark of Linotype Corp. and registered in the U.S. Patent and Trademark Office. It may also be registered in other jurisdictions on behalf of Linotype Corp. or its licensee Linotype GmbH, www.linotype.com.

Contact info

Autobahn
Stolte Rob
info@autobahn.nl
www.autobahn.nl
The Netherlands

Autobahn
Gelvetica

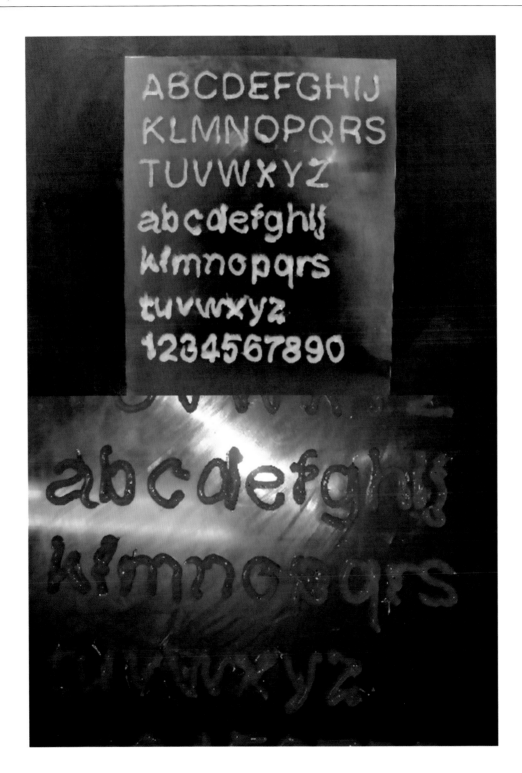

ABCDEFGHIJKLM
NOPQRSTUVWXYZ

abcdefghijklmnopq
rstuvwxyz

0123456789

Concept

This font was based on Helvetica and was made using toothpaste. The project was presented at Pecha Kucha in Amsterdam on December 25, 2008.

Helvetica is a trademark of Linotype Corp. and registered in the U.S. Patent and Trademark Office. It may also be registered in other jurisdictions on behalf of Linotype Corp. or its licensee Linotype GmbH, www.linotype.com.

Contact info

Autobahn
Stolte Rob
info@autobahn.nl
www.autobahn.nl
The Netherlands

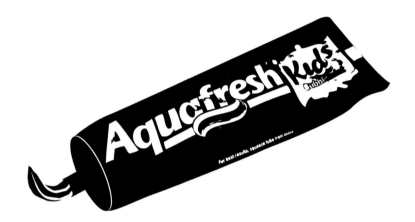

Autobahn

Heldentica

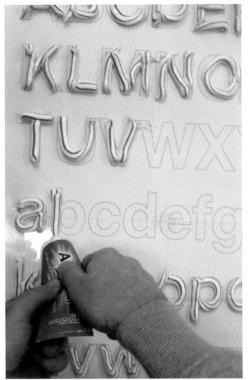

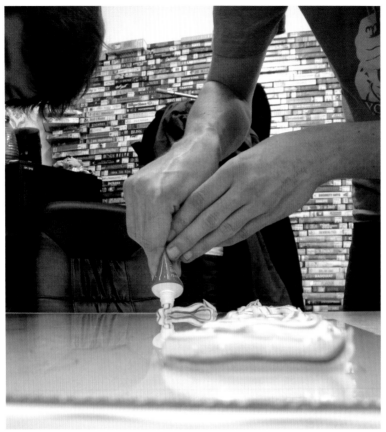

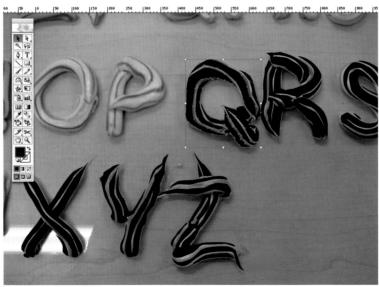

ABCDEFGHIJKLMN
OPQRSTUVWXYZ
abcdefghijklmnopq
rstuvwxyz
0123456789

Concept

This font was based on Helvetica and was made using ketchup. The project was presented at Pecha Kucha in Amsterdam on December 25, 2008.

Helvetica is a trademark of Linotype Corp. and registered in the U.S. Patent and Trademark Office. It may also be registered in other jurisdictions on behalf of Linotype Corp. or its licensee Linotype GmbH, www.linotype.com.

Contact info

Autobahn
Stolte Rob
info@autobahn.nl
www.autobahn.nl
The Netherlands

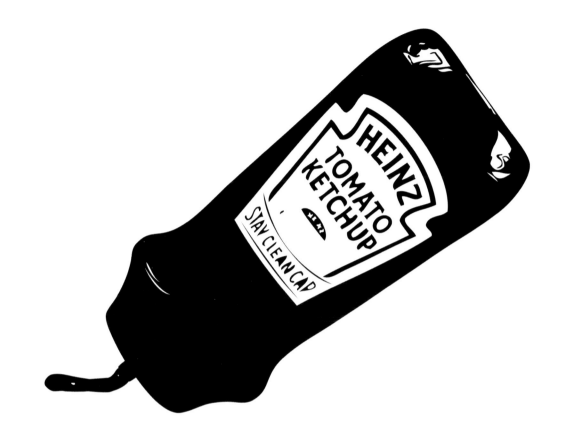

Autobahn
Tomatica

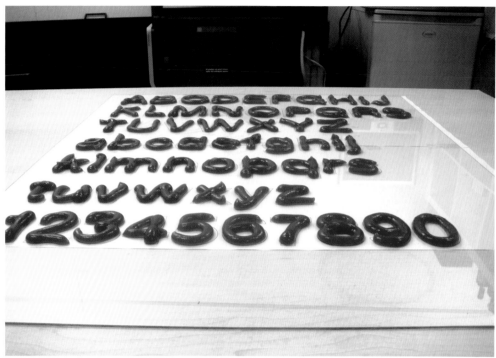

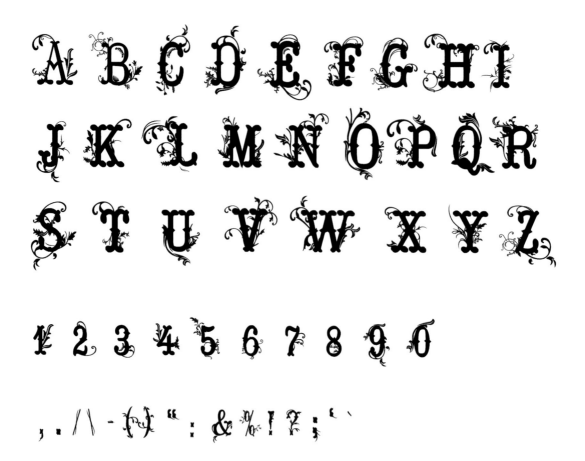

Concept

This font was based on an ornamental style. I was doing a project for a client that needed an ornamental font and thought, "Why not design my own that's better suited to the needs of the project?"

Contact info

Belinda Conceição de Carvalho
misscarvalho@gmail.com
Portugal

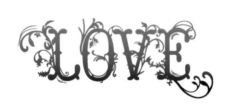

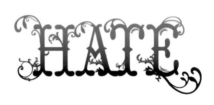

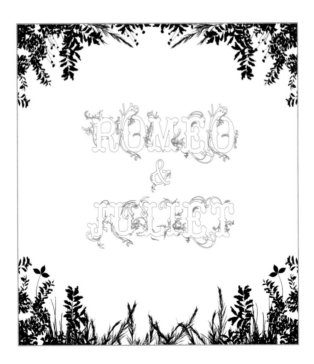

ABCDEFGHIJKLM
NOPQRSTUVWXYZ

ABCDEFGHIJKLM
NOPQRSTUVWXYZ
1234567890

Concept

The Bastard family is a modern, caps-only family of display fonts with OpenType features. The Bastard family includes a bold, a monotype and a rounded font.

Contact info

Lorenzo Geiger
hello@lorenzogeiger.ch
www.lorenzogeiger.ch
Switzerland

SOULDEPARTMENT FLOW

1 **RONNIE'S BONNIE** REUBEN WILSON
2 **FLOW** MARCO FIGINI
3 **SUNSHINE ALLEY** BUTCH CORNELL
4 **CPU** PHILIPPE KUHN
5 **ETERNALLY** GEORGE BENSON
6 **MIDNIGHT CREEPER** LOU DONALDSON
7 **BULLET HEAD** MARCO FIGINI

RECORDED AT FLÖTE4 · APRIL 26./27.2007 · WWW.FLOETE4.CH
MIXED BY ROLF STAUFFACHER, SIMON KISTLER, PHILIPPE KUHN
PRODUCED BY MARCO FIGINI AND PHILIPPE KUHN
PHOTOGRAPHY ART WORK MARCO GROB · WWW.MARCOGROB.COM
DESIGN LORENZO GEIGER · WWW.LORENZOGEIGER.CH

SOUL DEPARTMENT WOULD LIKE TO THANK FRITZ OTT, MARCO GROB,
LORENZO GEIGER, NOERBS, ROLAND PHILIPP, JANINNE, CHE DIETIKER,
ROLF STAUFFACHER, SIMON KISTLER

MARCO FIGINI PLAYS GIBSON L-5 WITH P90 PICKUPS AND FENDER TWIN AMP
PHILIPPE KUHN PLAYS HAMMOND ORGAN AND LESLIE SPEAKERS
ROBERT WEDER PLAYS ISTANBUL CYMBALS
MONDSTEIN RECORDS LC 15958 · ALL TITLES PUBLISHED BY SUISA

MONDSTEIN Records

CONTACT MARCO.FIGINI@BLUEWIN.CH · WWW.SOULDEPARTMENT.CH

SOULDEPARTMENT FLOW

E BAND

YS / DIE BEATLES
THE COMMODORES

DIE ANIMALS / EL ART OF NOISE
IL BLUE NILE / THE LA
EL BOX TOP / DAS CRAMP / LES BEACH BO
LE CARS / DER CULT / T

TH

URE

LE CU

S

DAS DOORS

ABCDEFGHIJKLMN
OPQRSTUVWXYZ
BASTARD EXTRABLACK
ABCDEFGHIJKLMNOPQRSTUVWXYZ

CK BAND

EL CLASH / DER CULT
THE DAMMED / EL FACES
DIE FATBAC
THE JAM

I EL FALL

ABCDEFGHIJKLMN
OPQRSTUVWXYZ
BASTARD BOLD
ABCDEFGHIJKLMNOPQRSTUVWXYZ

MO

LES DRIFTERS / DIE HEPTONES

THE I

TD–BASTARD 07
TRY'N'BUY: WWW.LORENZOGEIGER.CH

DERN

ABCDEFGHIJKLMN
OPQRSTUVWXYZ
BASTARD ROUNDED
ABCDEFGHIJKLMNOPQRSTUVWXYZ

VERS

LO

EL KILLERS

E JB'S / EL RED KRAYOLA
LE TUBE

AN OPENTYPE SIX WEIGHT CAPS ONLY HEADLINE FO
DAS POP GROUP / IL POLICE / THE RAMONES / THE
DER PRETENDER
IL SHINS / THE STREETS

EL KLF

ABCDEFGHIJKLMN
OPQRSTUVWXYZ
BASTARD ULTRABLACK
ABCDEFGHIJKLMNOPQRSTUVWXYZ

G PRESENT

LE RONNET
DIE TEMPTATIONS / THE UNDERTONES

ABCDEFGHIJKLMN
OPQRSTUVWXYZ
BASTARD BLACK
ABCDEFGHIJKLMNOPQRSTUVWXYZ

LE WEDDIN

GROUND

THE WHO

ABCDEFGHIJKLMN
OPQRSTUVWXYZ
BASTARD MONO
ABCDEFGHIJKLMNOPQRSTUVWXYZ

LE VELVET UNDERG
IL VERVE / THE YOUNG GODS

NORDEN
BASTARD BOLD

RADIO
BASTARD BLACK

BÜRO
BASTARD ULTRA BLACK

EXTRA
BASTARD EXTRA BLACK

WONDER
BASTARD BOLD

FATBOY
BASTARD ROUNDED

12490
BASTARD NUMBERS ALL WEIGHTS

MINUSKEL
BASTARD MINUSCULES ALL WEIGHTS

MONO
BASTARD MONO

FIRE WALK WITH ME
BASTARD BLACK

M.A.N.
BASTARD EXTRA BLACK

abcdefgh
ijklmnopq
rstuvxy wz
0123456789
. , ; : ` ´ ^ " " \ ! ? /

Concept

Batarkham features modern shapes and curves that are hard, but also somehow soft. It was inspired by the daily life of a big city, where time passes quickly and eyes are constantly looking at everything, consuming everything. It is a strong font.

Contact info

Lisboa Design
paulo@lisboadesign.com.br
www.lisboadesign.com.br
Brazil

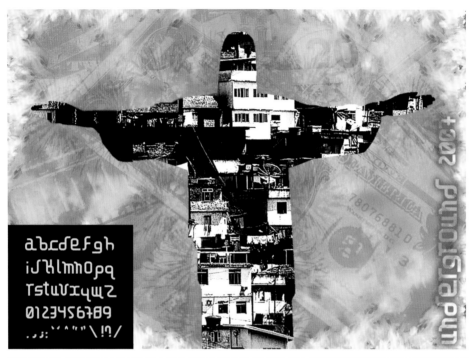

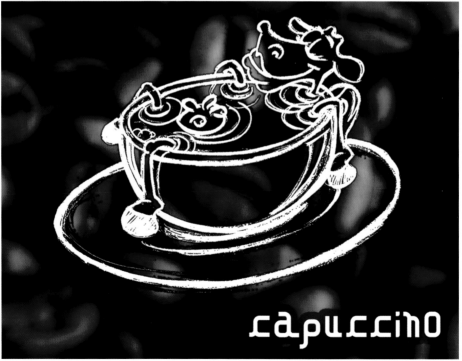

ABCDEFGHIJKLM

NOPQRSTUVXYWZ

0123456789

∴, ¡!? –> < + ✛O A

Concept

This font lay forgotten in the corner of the company for a while, until it was finally recovered for sale as a "toy". It was inspired by punks who spend hard-core nights drunk on wine. It comes with irregular forms evoking punk-rock imagery.

Contact info

Estranho Tipo
Adreson Vita de Sá
adreson@gmail.com
www.adreson.com
Brazil

<<<<<<<<<<<<<<<<<<<<<<<<<<<<<<<<(<)>>>>>>>>>>>>>>>>>>>>>>>>>>>>

BEBETE

<<<<<<<<<<<<<<<<<<<<<<<<<<<<<(<)>>>>>>>>>>>>>>>>>>>>>>>>>>>>

PIN-UP PUNK ROCK

AND GOTHIC GIRLS

ANGRY PUNK GIRLS OF THE WORLD

LANCHERA　　　　　BAR JOÃO　　AFU!

ALTERNATES　　　ANTIQUED

CLARENDON PESADA

DECORATIVE TATTOO

CORROÍDA DECAYED
EXPERIMENTAL

CHINELAGEM ALTERNATIVE
OCIDENTE

POST-PUNK CONHAQUE PINGABAMBU'S
INDIE

VINHO NOSSO BAR BOMFIM

FEMALE POST-ROCK PORTO GARAGE
REDENÇÃO

DESTRUCT EGYPTIAN FUNNY GRUNGE HEADLINE
HEAVY LETTERPRESS POSTER PUNK PUTARIA
ROUGH RUSTIC BEBEDEIRAS TRASH MOVIES SERIF SLABSERIF
WILDWEST BROKEN CRAZY DAMAGED BAGACEIROS DESTRUCT GRUNGE HEAVY

DECAYED EXPERIMENTAL ALTERNATIVE FEMALE GARAGE INDIE POST-PUNK BAR JOÃO OCIDENTE BOMFIM PINGA VINHO CONHAQUE TATTOO
LANCHERA PIN-UP PUNK ROCK AND GOTH GIRLS AND GHETTO AND GOSTOSAS CA BEBETE CORROÍDA ESTRANHO OTHER

?¿?

GARAGE MÚSICA BAR JOÃO CAÑA
DESTRUIÇÃO, GELÉIA E CACHAÇA

ROCK

BEBETE

ANGRY PUNK GIRLS OF THE WORLD!

!"#$ '()*+, -./0123456789:;< =>?
@ABCDEFGHIJKLMNOPQRSTUV
WXYZ[\]^_`ABCDEFGHIJKLMN
OPQRSTUVWXYZ[|]~
¡¢£¤¥¦ ¨©Aª«®°±²³´µ·¸¹º»¼
½¾¿ÀÁÂÃÄÅÆÇÈÉÊËÌÍÎÏÐÑÒÓÔÕ
Ö×ØÙÚÛÜÝÞ ÀÁÂÃÄÅÆÇÈÉÊËÌ
ÍÎÏðÑÒÓÔÕÖ÷ØÙÚÛÜ ÞŸŒœŠšŸ
žŽƒ ˆˇ˘˙˚˜ – —''‚ ""„ †‡•…‰ ‹›€ ™ –

ANGRY PUNK GIRLS OF THE WORLD!

1U$ONLY
BORRACHOS OF THE
WORLD EMBRIAGAI-VOS

PIN-UP
PUNK
ROCK

GARAGE MÚSICA BAR JOÃO CAÑA
DESTRUIÇÃO, GELÉIA E CACHAÇA

`` ©A «®° ±²³´µ·‚¹º»¼

ÄÄÅÆÇÈÉÊËÌÍÎÏÐNÒÓÔÕ
ÜÝþ ÀÁÂÃÄÅÆÇÈÉÊËÌ
ÔÕÖ÷ØÙÚÛÜ þŸŒœŠšŸ
—‚', ""„ †‡•…% <>€ ™ –

ERGROUND

GIRLS OF THE WORLD!

ONLY PIN-UP
 OF THE PUNK
RIAGAI-VOS
A BAR JOÃO CAÑA ROCK
GELÉIA E CACHAÇA

«««««««««««<>»»»»»»»»»»»»»

«««««««««««<>»»»»»»»»»»»»»

BETE
PUNK GIRLS OF THE WORLD!
)*+, -./0123456789:;< =>?
EFGHIJKLMNOPQRSTUV
\]^_ `ABCDEFGHIJKLMN
STUVWXYZ[|]¯
`` ©A «®° ±²³´µ·‚¹º»¼
ÄÄÅÆÇÈÉÊËÌÍÎÏÐNÒÓÔÕ

GARAGE MÚSICA BAR JOÃ
DESTRUIÇÃO, GELÉIA E
«««««««««««««««««««

«««««««««««««««««

BEE
ANGRY PUNK G
!"#$ '()*+,
@ABCDEFGHI
WXYZ[\]^_`
OPQRSTU
¡¢£¤¥¦ `` ©A
½¾¿ÀÁÂÃÄÅÆ
Ö×ØÙÚÛÜÝþ
ÍÎÏÐNÒÓÔÕÖ÷
ŽŽF¨¯ —‚',

¥230
ANGRY PUNK GIRLS OF
1U$ON
BORRACHOS OF TH
WORLD EMBRIAGAI-
GARAGE MÚSICA BAR JOÃ
DESTRUIÇÃO, GELÉIA E
«««««««««««««««

47

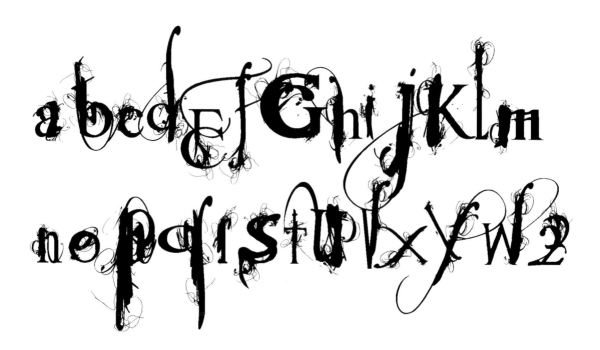

Concept

An experimental font used mainly for posters and headlines. It is a freehand font and produces a strong graphic impact.

Contact info

Bechira Sorin
bechira.sorin@gmail.com
www.bechira.com
Romania

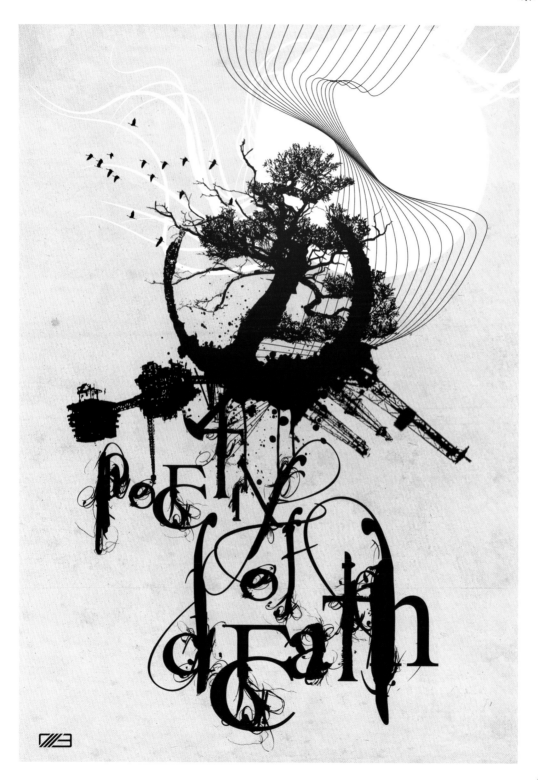

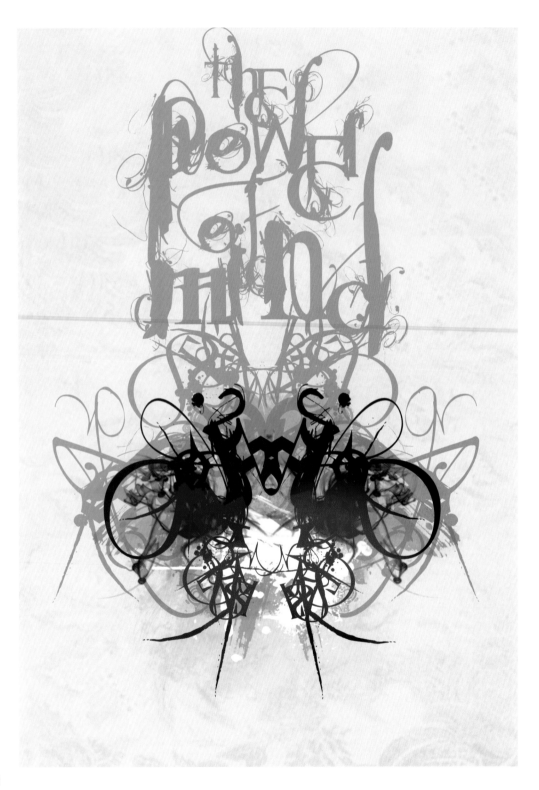

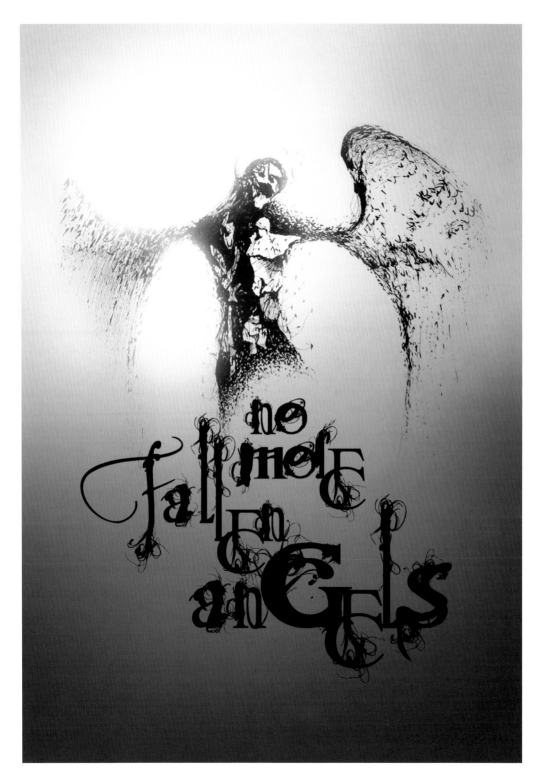

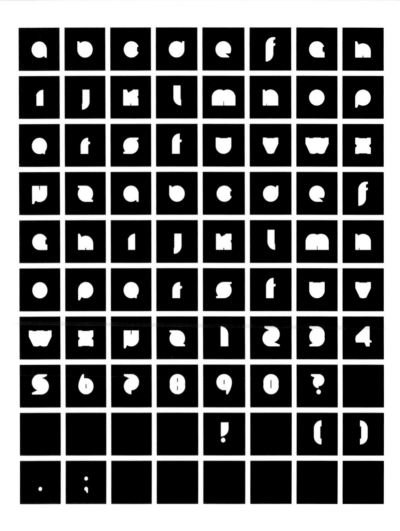

Concept

BigCircle is a graphic font developed from a single base shape: the circle. The design of each glyph has been pushed to the very limit of legibility. BigCircle was conceived for use in large headlines, but it also works well in visual identity and logo design projects.

Contact info

Designaside
Mauro Caramella
mauro@designaside.com
www.designaside.com
Italy

BigCircle

the quick
brown fox
jumps over a
lazy dog.

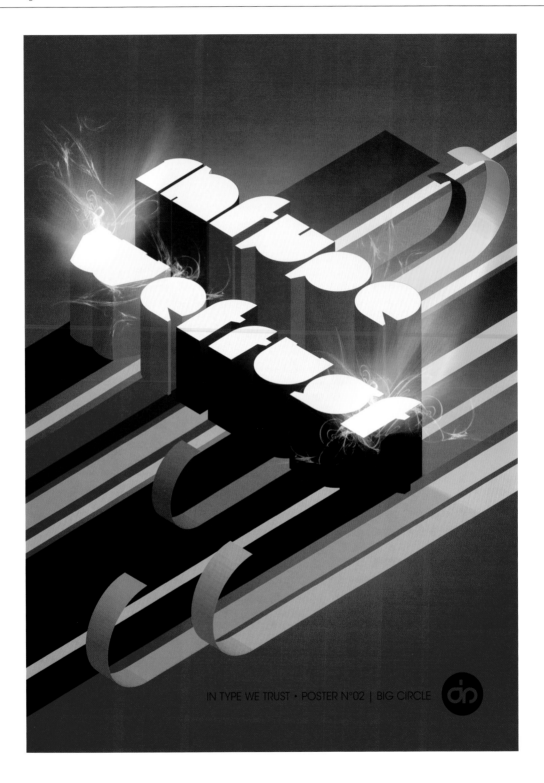

IN TYPE WE TRUST · POSTER N°02 | BIG CIRCLE

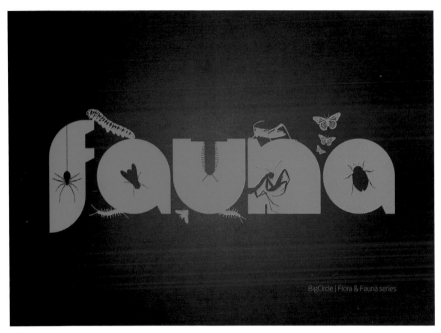

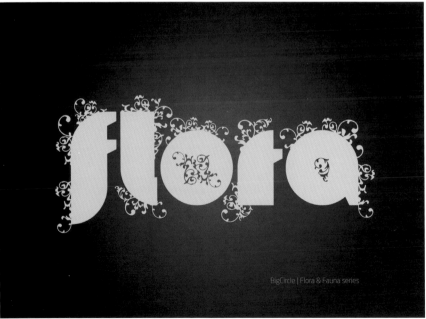

ABCDEFGHIJKLMNOPQRSTUVWXYZ

abcdefghijklmnopqrstuvwxyz

ÄöÜ1234567890

.,!?-§$/@

ABCDEFGHIJKLMNOPQRSTUVWXYZ

abcdefghijklmnopqrstuvwxyz

ÄöÜ1234567890

.,!?-§$/@

Concept

The idea behind Black Sirkka was to develop a modern interpretation of the blackletter typefaces. Black Sirkka is a bastardization with the typical features of a blackletter font, combined with the modern, simple shapes typical of a grotesque font. The whole typeface was built up using a modular construction system.

Contact info

Magma Brand Design (Volcano Type)
Sirkka Hammer
www.magmabranddesign.de
www.volcano-type.de
Germany

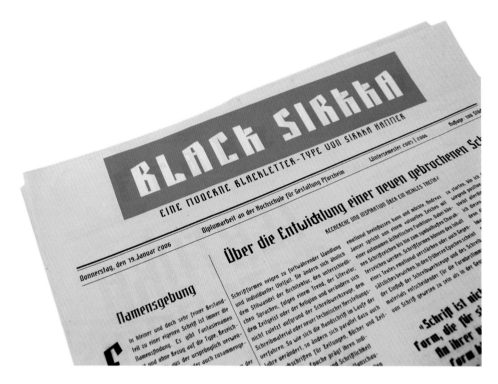

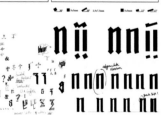

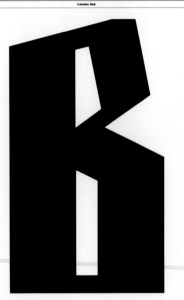

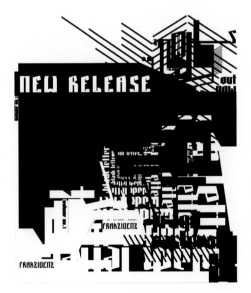

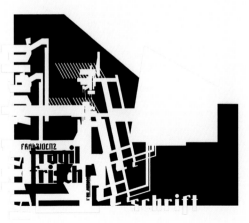

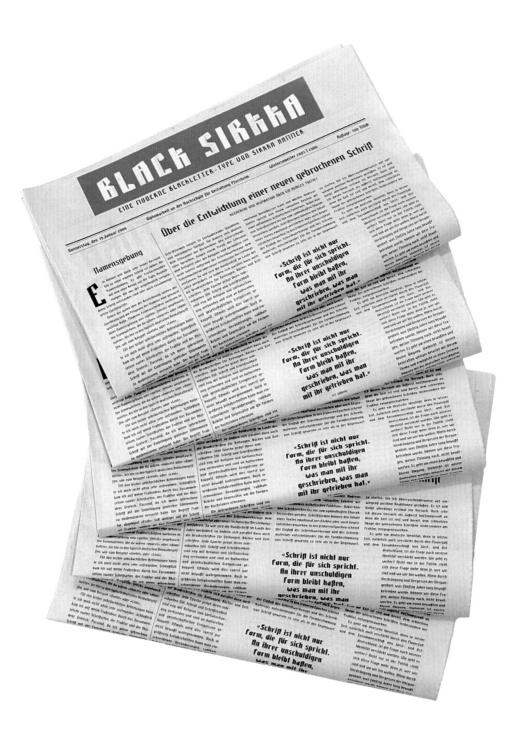

ABCDEFGHI
JLMNOPQR
STUVWXYZ
1234567890

Concept

A typeface developed for the private design consultancy of Cameron Ewing specializing in print, motion and web design.

Contact info

Staypressed Design
Cameron Ewing
contact@staypressed.com
www.staypressed.com
United Kingdom

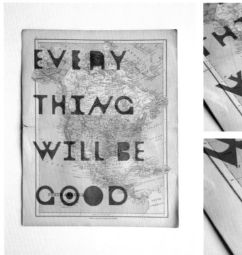

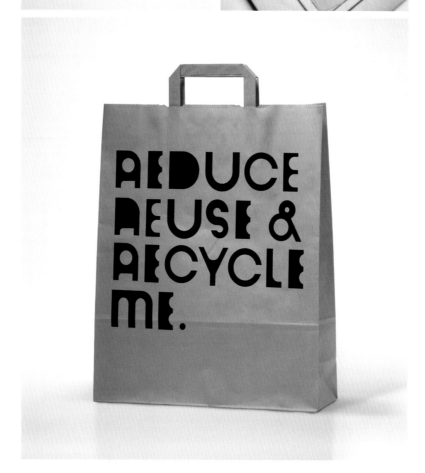

ABCDEFGHIJKLM
NOPQRSTUVWXYZ

abcdefghijklmnopq
mnopqrstuvwxyz

1234567890 :;,.!?"'/\

&£$@/+--[]*{}«»ß®©¿¡
èéêẽ()%×=™€ÈÉÊËÑ

Concept

One day when I was bored and just searching around, I got the idea of closing my eyes and letting chance do the creative work, instead of me consciously trying to design. I started by making random points and curves with the computer mouse and ended up with some really bizarre forms. Then I tried to make some letters. As the result was quite funny, I kept going on blindly making the other letters. Afterwards I worked on them to give the font some degree of coherence.

Contact info

Johnny Bekaert
jb@johnnybekaert.be
www.johnnybekaert.be
Belgium

bekaert visual designteam

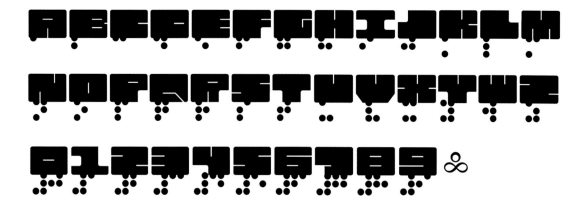

Concept

The Braille system, created by Frenchman Louis Braille in 1821, is a method that is widely used by blind people to read and write. Each Braille character or "cell" is made up of six dot positions, arranged in a rectangle containing two columns of three dots each. A dot may be raised at any of the six positions to form sixty-four (2^6) combinations, including the combination in which no dots are raised. The Braille Double System was developed in 2008 for the blind and non-blind alike.

Contact info

Mito Design
Pedro Guitton
www.mitodesign.com
Brazil

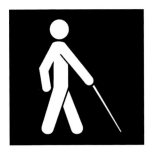

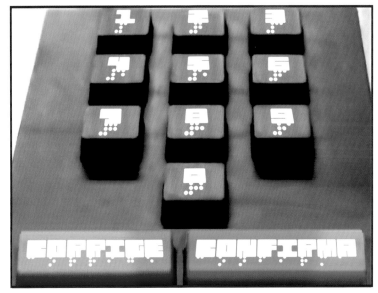

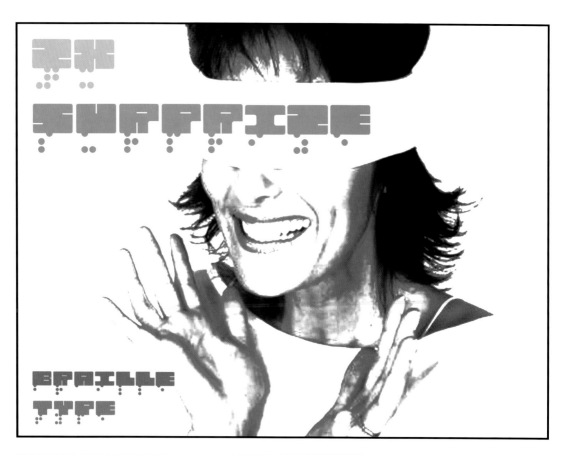

AaBbCcDdEeFfGgHhIiJj
KkLlMmNnOoPpQqRrSs
TtUuVvWwXxYyZz!Çç{}[]
1234567890®©\/÷·|><;:
¿~@$%&-_+= #^"´`Ø™€ …
ÕÓÒõóòêôÃÁÀãáàÂâíì
ÊÉÈñÑẽéèÍÌũúùŨÚÙ£✱

Concept

This font is bursting with Japanese inspiration. I love Japanese culture, games, animation, movies and even the language itself. Brusher, as the name suggests, was inspired by the brushes used in traditional Japanese writing and painting.

Contact info

Otávio Pereira Ribeiro
otaviopr@otaviopr.com
www.otaviopr.com
Brazil

Concept

Inspiration for this font came on a trip to London while waiting for the bus at the airport, and it was modeled after a short sketch of the bus display screen. A set of dingbats further broadens the font's spectrum of applicability. Bus was Volcano Type's first technical font and was the main font used in a corporate identity redesign for BERGAMONT Bikes in 2001/2002.

Contact info

Magma Brand Design (Volcano Type)
Lars Harmsen & Boris Kahl
www.magmabranddesign.de
www.volcano-type.de
Germany

CALL NOW
238-33-86
778-98-94
411-02-32

060061 P LUCY CRISTINA FOR WOM ; MÜNCHEN, 2002
 F 065 ; NORMAL

GIVENCHY T MOULINEX
RAF ▓ IRR

084087 F 065 ; 74
 F 08086 ; EXTENDED

greenpeaceamnesty

164165 P X-FORM & KARLSRUHE, 2001

F BUS & PI
TACORA

ABCDEFGHIJKLMN
OPQRSTUVWXYZ
1234567890 .:;,
%£@$€()&!?=+×
©®{}ÈÉÊËÑÇ¿¡•
/<><>≈ ™* _ _ _ ''"" °

Concept

The idea here was to get rid of baselines and letter heights to make it look almost as if the characters were dancing on paper. When designing the font, I had to be very spontaneous and direct and not bother with issues such as construction or form. So, I made words quickly, clicking with the mouse, drawing the same letters interacting with each other in different ways. This direct approach resulted in a paper-cut effect.

Contact info

Johnny Bekaert
jb@johnnybekaert.be
www.johnnybekaert.be
Belgium

ABCDEFGHIJKLM
NOPQRSTUVWXYZ
1234567890

Concept

Camino is a new, highly authentic Spanish bar and restaurant in London. "Camino" means road, way or path in Spanish. The typeface is a complete alphabet and was hand-drawn from a few characters found on an original Spanish street sign. The logo is also unique to its location. "Cruz del Rey" is Spanish for "King's Cross", the area in London where the restaurant is located.

Contact info

The Formation Creative Consultants Ltd
Adrian Kilby
akilby@theformation-cc.co.uk
www.theformation-cc.co.uk
United Kingdom

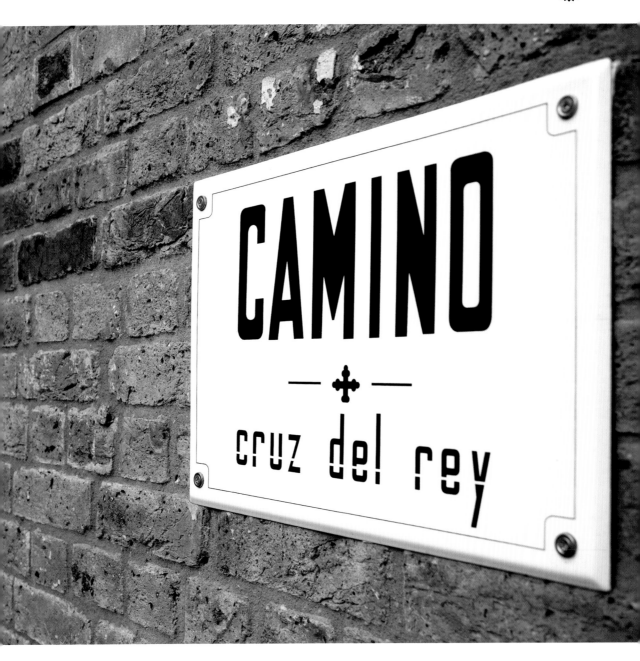

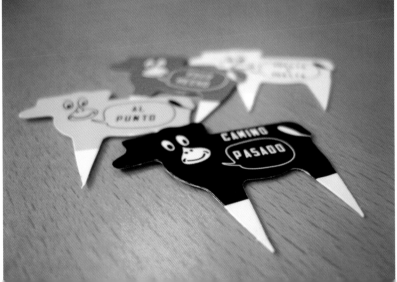

a b c d e f g h i j k l m
n o p q r s t u v x y w z

a b c d e f g h i j k l m
n o p q r s t u v x y w z

1 2 3 4 5 6 7 8 9 0

? ¿ () () [] & $. , : ; ‾ ` ^ ˚˚ ‹›

Concept

Caqui Chocolate was created as part of the new visual identity for the Caqui Communication Agency. Based on neon lights, this font was developed as a hybrid of designs that are older than neon would suggest but given a more modern touch. The use of ornamentation that departs from the conventions of proper typography allows for a great variety of creative compositions.

Contact info

Alisson Ribeiro
alisson.contact@gmail.com
www.flickr.com/photos/designal
Brazil

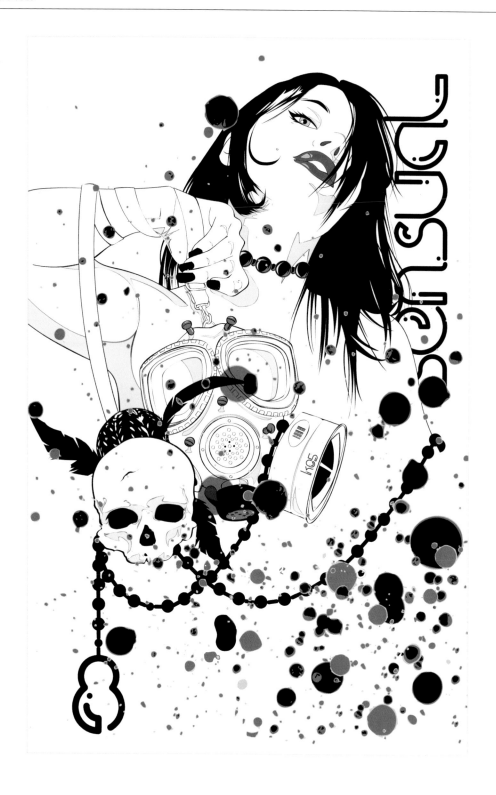

ABCDEFGHIJKLM
NOPQRSTUVWXYZ

abcdefghijklm
nopqrstuvwxyz

0123456789 0

,-.?

Concept

In an effort to come up with new grid font forms, I began with an analysis of existing grid fonts, scanning through their special properties to identify their source of inspiration. I then chose packaging as the inspiration for Case. This font did not come out as italicized as I had expected, and in the end, it is more of a design element for use in the development of new language forms.

Contact info

Paolo Monaco
paolo@monacografico.ch
www.monacografico.ch
Italy

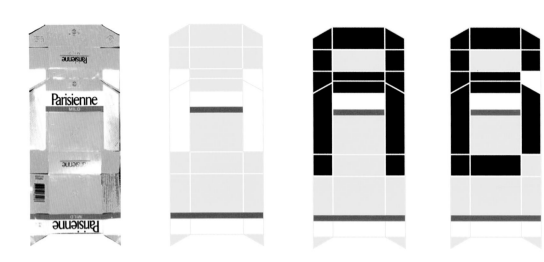

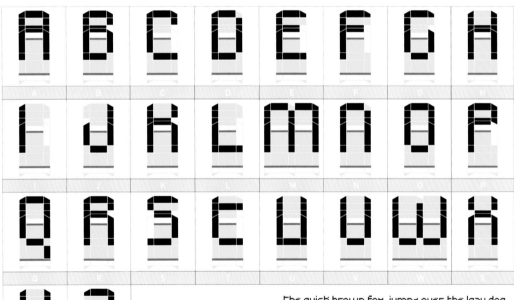

the quick brown fox jumps over the lazy dog
THE QUICK BROWN FOX JUMPS OVER THE LAZY DOG

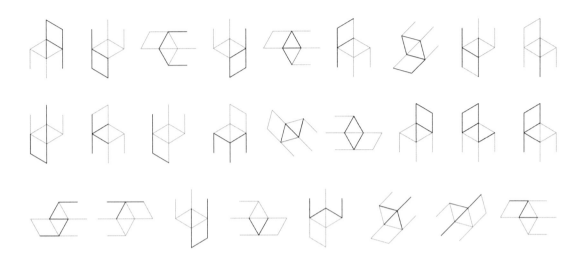

Concept

This font was designed for a furniture shop using simple lines to evoke the basic shape of a chair, which is a very essential piece of furniture.

Contact info

A Beautiful Design
Roy Poh
roy@abeautifuldesign.com.sg
Singapore

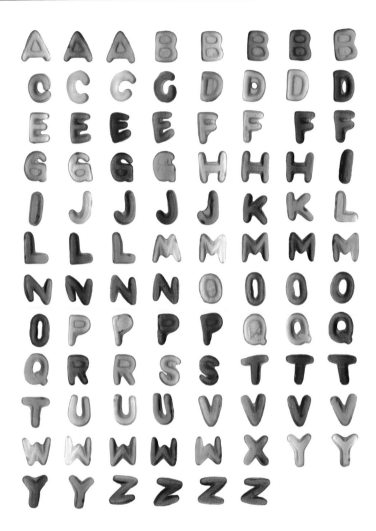

Concept

Chuches was handmade from pieces of candy. Each letter is available in several different colors.

Contact info

Laura Millán
pitijopo@gmail.com
www.lauritamillan.es
www.ipp4films.net
Spain

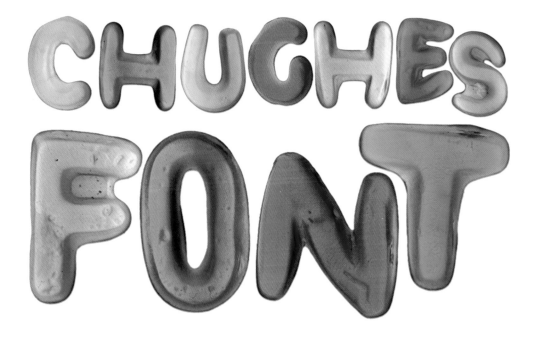

Concept

CODA 4X4 was created as the cornerstone of a brand identity program for CODA, a young, contemporary architecture firm. Paradoxically, the typeface's quirky personality is a result of strict adherence to an underlying structure which remains visible in the final executions. This philosophy is a direct reference to CODA's architectural design process. The typeface is rendered in any number of "finishes" in the final executions, the result being an infinitely flexible identity program held together by a very strict structure.

Contact info

Block Branding
someone@blockbranding.com
www.blockbranding.com
Australia

A B C D E F G H I J K L M
N O P Q R S T U V W X Y Z

a b c d e f g h i j k l m n
o p q r s t u v w x y z ß

0 1 2 3 4 5 6 7 8 9

€ $ & £ ¥ % ¢ / © ™

» . , : ; - (! ?) ... @ «
{ Ä Ö Ü ä ö ü æ }

Concept

If you take a moment to look at the old masterpieces of handcrafted typography, you will notice lots of irregularities and imperfections. These added life and suspense to the fonts. Imperfection is needed to create true beauty, and that is the underlying concept behind this sans-serif font.

Contact info

Cape Arcona Type Foundry
Claudius Stefan
stefan@claudius-design.de
www.cape-arcona.com
Germany

VOLVO PENTA UND THE SA- MUEL JACKSON 5 AUS NORWE- GEN SPIELEN AM 30. OKTO- BER 2008 UM 20 UHR INSTRU- MENTALMUSIK IM STEINBRUCH IN DUISBURG.

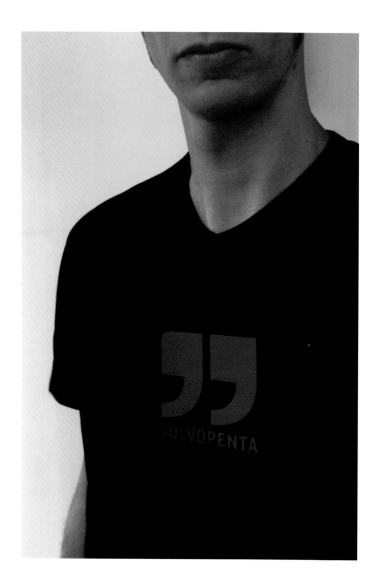

ABCDEFGHIJKLMNOPQRSTUVWXYZ
abcdefghijklmnopqrstuvwxyz
1234567890
ÄÖÜäöü !?"/()=

Concept

Creatinin Pap is based on an old Scrabble-style letter game to help kids learn the alphabet that I once found in my grandparents' basement.

Contact info

Polenimschaufenster
office@polenimschaufenster.com
www.polenimschaufenster.com
Austria

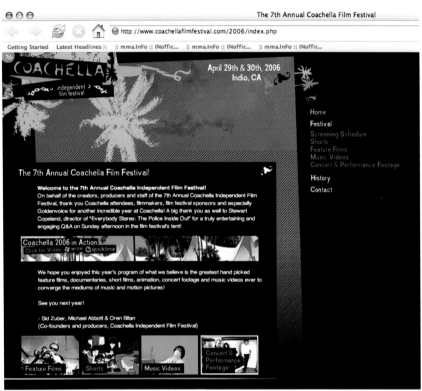

JACK

HE WAS ALONE
TRAPPED INSIDE
EMOTIONLESSLY STARING
AT THE RIVER SIDE
THESE PICTURES STAY
RUNNING THROUGH HIS HEAD
DIVIDING HIM, DISCHARGING HIM
AND DRIVING HIM SO MAD

THE LAST REMAINING FLAME
IN A WORLD SO COLD
GOES AWAY, FADES AWAY
NO MORE HAND TO HOLD
WONDERING IF THIS IS STILL
THE GOD I USED TO TRUST
THAT THERE'S A MASTERPLAN
TAKE HER IF YOU MUST

YOU GOT TO GIVE UP
GOT TO LET GO RELAX
FALL BACK
GOT TO COPE WITH IT
GOT TO COMPOSE
ARRANGE
GET ON (GET ON)

HE LOOKED AT HER
HOW SHE GOT UP LIKE EVERYDAY
SHE TOOK HIS HAND AND ASKED
IF EVERYTHING'S OKAY
WORLD'S SPINNING FASTER THAN BEFORE
WITH ALL THE MEMORIES WASHED ASHORE
BELIEVE IN VIRTUES IN YOUR HEAD
THE MORNING IS PRAISED UNLESS SHE SAID

BACK TO THE ROOTS

SHE TOLD ME
I WILL NEVER UNDERSTAND
WHY THEY NEVER SAY WHAT THEY MEAN
THEY YELL WE DON'T CARE
I KNOW WE DO CARE
HE'LL PRETEND HE FORGETS
UNTIL HE PETS THE SECRETS
STRAYING ROUND IN THE DARK

WE WANNA SAY IT'S TIME
TO LEAVE THIS PLACE
AND LOOK AROUND
WE WANNA CHANGE OUR MINDS
AND LEAVE ALL THE SHIT BEHIND
WE'RE GOING BACK TO THE ROOTS

SHE TOLD ME I WILL NEVER UNDERSTAND
WHY THEY TEND TO TATTLE IN PAIRS
IT'S A PITY THAT HE'S NOT PRETTY
HE'LL STAND THE TEST AND SHOW THE WORLD
HE FITS INTO THE STYLE LIKE A GLOVE

WE WANNA ACT ON YOUR ADVICE
WE WILL GROW STIFF AND ROLL THE DICE
WE CAN CALL IT THE CONSEQUENCE
OF CONVENTIONS AND OFFENSE

IT SEEMS SO AWESOME TO ME
WE'RE GOING BACK TO THE ROOTS

SHE TOLD ME NANANANANANA
SHE GOT IT SHE'S SO
SHE GOT IT SHE'S SO LOVELY AT ALL

SWEEPING

HAVE YOU EVER THOUGHT OF LIVING ON THE DOLE
TRY TO IMITATE THE LIFE OF YOUR IDOL
YOU WANT TO FACE IT COME ON JUST EMBRACE IT
SPELL IT AND REPHRASE IT DID YOU LICK AND TASTE IT
THIS LIFE IS MORE THAN JUST OBEYING IN A MAN
HOW CAN I SAY I'M YOUR BIGGEST FAN
HE WANTS THE PEOPLE DOING WHAT HE NEVER CAN
AND BOMBS A LAND EVERY NOW AND THEN

TURNING ON THE TV NOW YOU GONNA SEE OH
VI.VA. NO, WATCHING ALL SHIT WOH
WHAT I DON'T KNOW IS, WHY THEY GONNA DO THIS
WHO THE FUCK WILL WATCH THIS, DON'T YOU KNOW THAT I'M PISSED
THE FABULOUS LIVES OF CELEBRITIES UNCENSORED
THE BEST OF HUNDRED BODIES LET ME NOW FORGET WHAT I'VE HEARD
SOPHISTICATED GOSSIP APPROACHES ON THE SURFACE
HAVE YOU HEARD, HAVE YOU HEARD, MARTHA SINGS IT HURTS

TAKE THEM DOWN TO EARTH
THEY'RE NOT THE MASTERMINDS
IT'S BECAUSE WE'VE BEEN BLIND
IT'S THAT WHAT THEY DESERVE

ZAPPING THROUGH THE CHANNELS, GETTING SICK OF ALL THAT SHIT
FLOODING MY MIND, SO WHAT YOU GONNA SAY KID
BOOSTING ALL THE NEWS, AN EXAMPLE OF ABUSE
THEY MAKE ME GET THE BLUES, BUT I STILL CAN'T REFUSE
MONEY IS LIKE HONEY FOR THE BEES AT THE STOCK
EXCHANGING SOULS FOR MONEY REARRANGE YOUR THOUGHTS, FUCK
EXPLOITATION AND FRUSTRATION CAUSED BY THE SOFTENING OF THE BRAIN
WE ARE GETTING INSANE

IS IT TRUE
THAT WE ARE FAILING
ABERRATION IN A DEAD END
DO YOU BELIEVE?

SAY HELLO

I TURNED AROUND, IT WAS A MOMENT WHEN I SAW HER
BETWEEN THE PANTS AND BOXERS, SKIRTS AND PUSH-UP BRAS
SHE WALKED ON BY AND I NEARLY FAINT
IT'S YOU, YEAH

HEY YOU, COME BACK AND LET ME SAY HELLO
I FEEL LIKE WE HAVE MET BEFORE
JUST LET ME SING ANOTHER SONG FOR YOU
THERE'S NOTHING THAT I WANT MORE

SHE LEFT THE STORE, I TRIED TO CHASE
AND IF I CAN, I'D FIND HER PLACE
BUT ANYWAY, I HAD TO TALK WITH HER BEFORE
I KNOW THAT SOMETIMES THINGS TURN OUT TO BE HARD CORE

I COULD CONVINCE MYSELF
TO TAP HER ON THE SHOULDER
HER AGE WAS PERFECT
CAUSE I WAS OLDER
A CAR STOPPED BY
AND SHE WAS GONE WITHIN A SECOND
I WAS JUST STARING
COULD THIS BE THE END
AS I TURNED ROUND
I HEARD A BANG WITHOUT A DOUBT
I WAS SO HAPPY
THE CAR HAD A BLOWOUT
I STARTED TO RUN I KNEW
THAT NOBODY COULD STOP ME
I REACHED THE FRONT DOOR

ABCDEFGHIJKLMN

OPQRSTUVWXYZ@

abcdefghijklmnopqrs

tuvwxyz.!áàâäñçfifl)

0123456789}

Concept

Family: Light, Regular, and Bold. A typeface based on "crespells", a type of sweet.

Contact info

Dúctil
Damià Rotger Miró
ductil@ductilct.com
www.ductilct.com
Spain

Ricardemòjamfü...

Crespell

estricngremyos

njue icñ

136 imjhak

imzevçu

mrkjùfet

Quokigen

ABCDEFGHIJKLMNOPQRSTUVWYZ

Jaskijón...

kenj, ompe

estrin.okux.

Gimgrwayto

wentrinprokjémòhi

abcdefghijklmnopqrstuvwyz

Crespell Light
Crespell Regular
Crespell Bold
Dolç vs Salat
Carquinyols
Mitja lluna
¡zabrosso 24
Figures de mati
Oli i aigu amb figues
Ensaimada i xoco
Ginebre ferida

que desde Mar-
uel 9 de febrero
e los farallones y
je desapareció
bo un supervi-
más joven de la
miento el 20 de
ernar los repeti-
Para su cons-
sportar los ma-
l camino de
Y el de Cavalle-
a las 36 millas. El
de la isla des-
ta de Sant Car-
tillo de Sant
r brújula, Cava-

emanan historias de soledad, de mares re-
belados, de naufragios y de heroicidades.
Lástima que los faros de hoy estén todos
automatizados, porque el silencio de los
fareros es una música callada que, sin decir
nada, lo dice todo".

Testigos y víctimas del progreso a la vez, el
primer sistema de iluminación fue por vapo-
rización de petróleo. Método substituido en
los años 30 por el de acumuladores de ace-
tileno y la electricidad. Pero a partir de los
70 llegó la automatización y el progresivo
abandono de un oficio y de edificios que han
generado no pocas leyendas. <<

motivo hace re-
hora de
que resulta
playa a comer
as. En estas
bles las facili-
mantener los
en un
cual
cierta
nos más
mienda una
tos a la hora
en verano
uerpo
o cuerpo
los meses

últimos años, como enfermedades de tipo car-
diovascular, el cáncer, como puede ser el de piel,
o incluso enfermedades asociadas con el enve-
jecimiento de las personas, como las cataratas y
las alteraciones nerviosas.

Es durante el verano cuantos más casos de into-
xicaciones alimentarias se dan, y por lo tanto es
importante llevar una dieta sana y equilibrada,
basada sobre todo en beber mucha agua y en
consumir alimentos ligeros y refrescantes, como
las frutas y verduras de temporada, que nos
aportan agua y nutrientes de la forma más ape-
titosa y refrescante posible. <<

a la incurabilidad de sus heridas. Estos reciben la visita de los
alumnos de Educación Ambiental, ya que el Centro permite la
visita organizada de los centros escolares de la isla, a los que
se les explica la manera de actuar ante un animal herido, las
funciones y objetivos del Centro de Recuperación y los proble-
mas que hoy en día afectan a las especies autóctonas de la isla.

El Centro de Recuperación de Fauna Silvestre tiene la finalidad
de contribuir al mantenimiento de la biodiversidad zoológica de
Menorca mediante la asistencia a la fauna silvestre accidentada
o en peligro y, paralelamente llevando a cabo la tarea educativa
y de concienciación sobre este tema. <<

scinados por cada
ser sus vistas y
xcio que se ofrece
s a la cueva por la
rrte en la puesta
lo chill out del
ección de los
a para acabar la
rada de la salida
cuenta con una
"Producciones",
y fue que
os de los ojs

aconalado, Xoroi se lanzó al mar que una
vez lo trajo a la isla, y su hijo mayor lo
siguó tirándose también al mar. La
mujer, junto con sus otros dos hijos fue
llevada a Alaior, donde vivieron y tuvieron
descendencia.

El lugar idóneo para pasar un agradable
dia de verano desde los pies a la cabeza
fusionando la cultura e historia de la isla
con su parte más divertida y refrescante.
<<

DAC MEDIUM
ABCDEFGHIJKLMNOPQRSTUVWXYZ
abcdefghijjklmnopqrstuvwxyz
0123456789 @$¥€£!i?™

DAC BOLD
ABCDEFGHIJKLMNOPQRSTUVWXYZ
abcdefghijjklmnopqrstuvwxyz
0123456789 @$¥€£!i?™

Concept

I work as a packaging designer and receive computer-generated cutter guides on a regular basis. Drawing inspiration from the type found on these cutter guides, I created DAC, a unique and modern display face intended to be used in a variety of situations.

Contact info

James Thompson
james@workandturn.co.uk
www.workandturn.co.uk
United Kingdom

ABCDEFGHI JKLMNOPQ RSTUVWXYZ

ABCDEFGHI JKLMNOPQ RSTUVWXYZ

Concept

Dino Mono is a monospaced, rounded, monoline grotesque font with OpenType features and is available in two weights.

Contact info

Lorenzo Geiger
hello@lorenzogeiger.ch
www.lorenzogeiger.ch
Switzerland

MARCO FIGINI
GUITARS

ABCDEFGHIJKLMNOPQRSTUVWXYZ

abcdefghijklmnopqrstuvwxyz

ŒŒÆÆfifflchchoecœeþß ª º

ÁÀÄÂÃÅÉÈËÊÍÌÏÎÓÒÖÔÕÚÙÜÛÇÑŠŽÝŸ

áàäâãåéèëêíìïîóòöôõúùüûçñšžýÿ

1234567890 ½¼¾ 123 +−×∗÷√=≈≠≤≥<>%‰\$€¢£¥

#&@¶†‡§©?¡!.,;:…°''""«»''""()[]{}|¦---/\™®©

Concept

Espiral was created at the National Autonomous University of Mexico and was selected for the 2008 Biennial of Latin Letters. The packaging featured here was designed by Guadalupe Apipilhuasco González.

Contact info

Lunar
Miguel Ángel Padriñán Alba
m.angel_pa@yahoo.com
Mexico

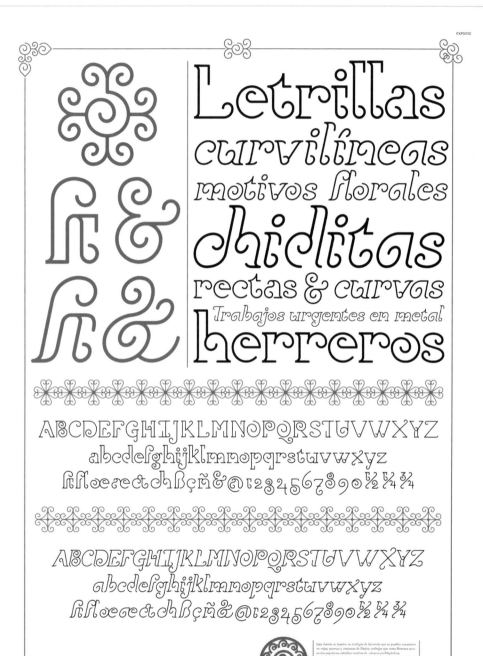

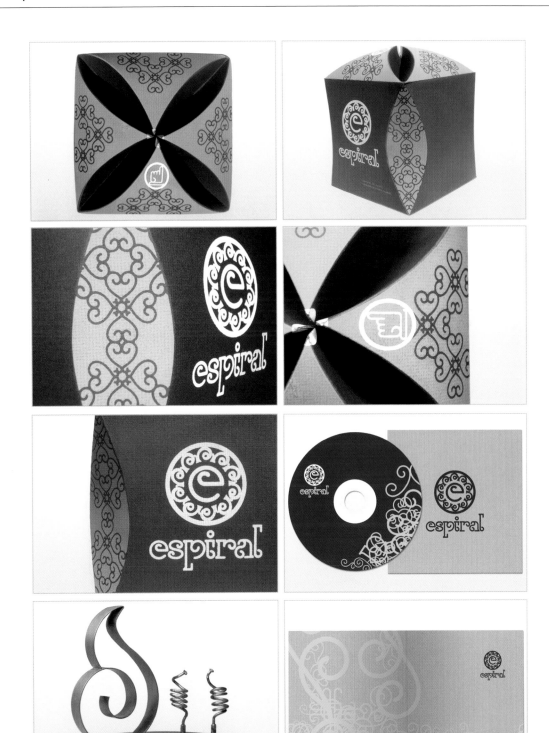

ABCDEFGHIJKL
MNOPQRSTUV
WXYZ
abcdefghijklm
nopqrstuvwxyz
1234567890
!@#():;<>,.

Concept

This font was based on markings on a soccer field and was designed for the 2008 Breda Graphic Design Festival poster. We used a chalk cart to draw letters on the field. The letters were then photographed by Jaap Scheeren.

Contact info

Autobahn
Stolte Rob
info@autobahn.nl
www.autobahn.nl
The Netherlands

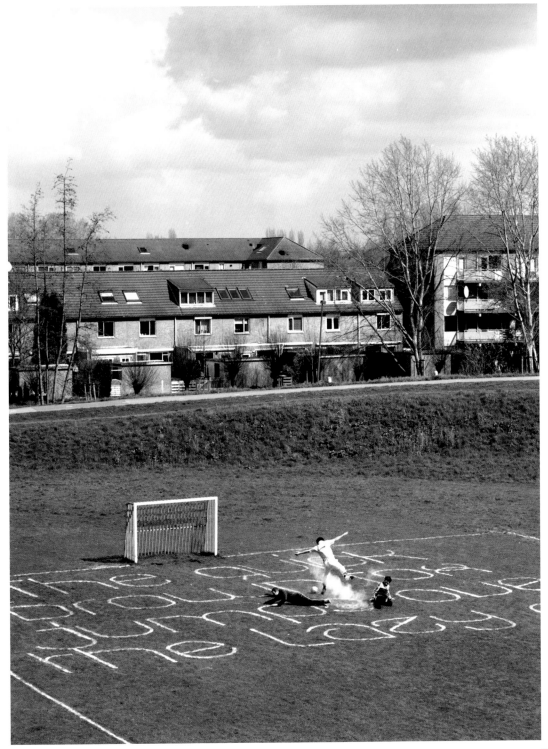

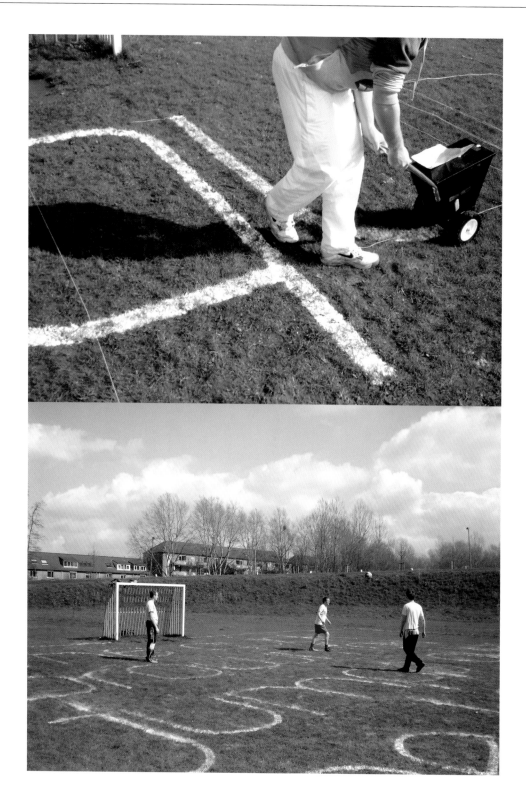

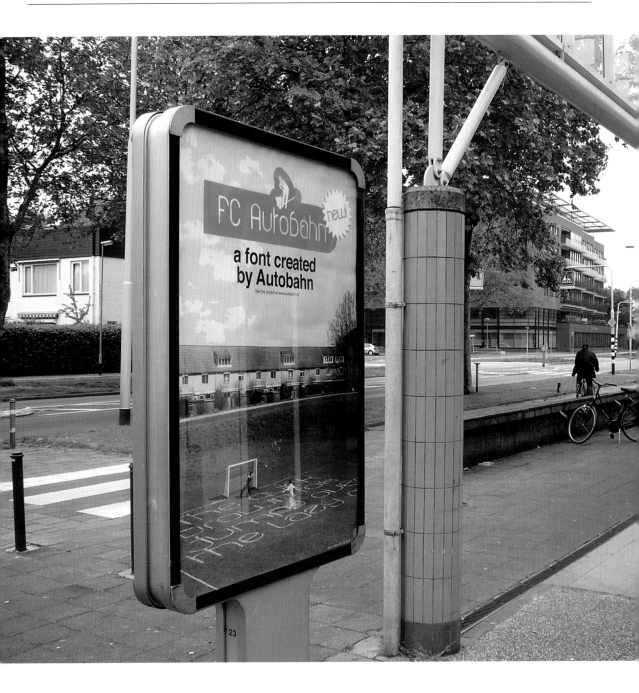

Concept

FLR-Cuadrant is a modular typeface based on a circle that was modulated to produce the glyphs.

Contact info

Aurelio Sánchez
aurelio@fluorink.net
www.fluorink.net
Spain

Concept

FLR-Expanded is a geometric typeface that was produced by expanding Verdana to produce block-like characters. In this form, the original font is totally unrecognizable. Little corrections were made to improve legibility.

Contact info

Aurelio Sánchez
aurelio@fluorink.net
www.fluorink.net
Spain

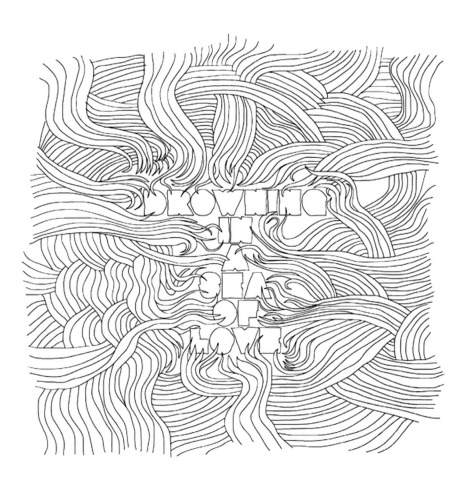

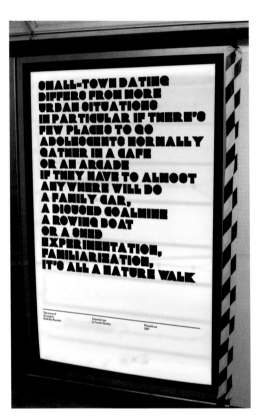

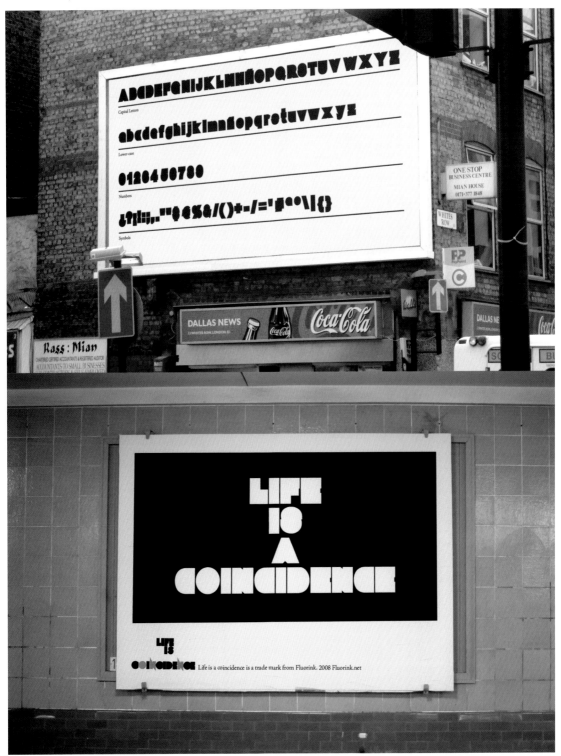

Concept

FLR-Technic is a modular typeface based on rectangles that have been rounded off on some of the corners. Go and repeat the pattern!

Contact info

Aurelio Sánchez
aurelio@fluorink.net
www.fluorink.net
Spain

juan
kevin
derrick
and
carl

detroit
motor
city

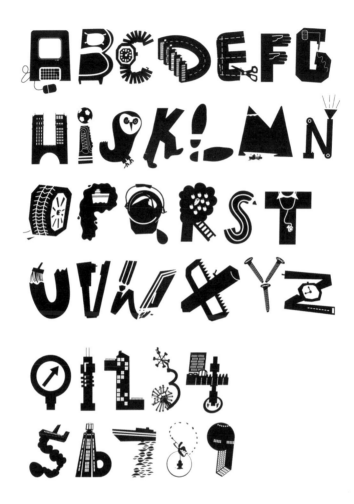

Concept

FP was specially made for use by the Folkpartiet political party in the 2006 Swedish elections.

Contact info

BankerWessel - Jonas Banker
jonas@bankerwessel.com
www.bankerwessel.com
Sweden

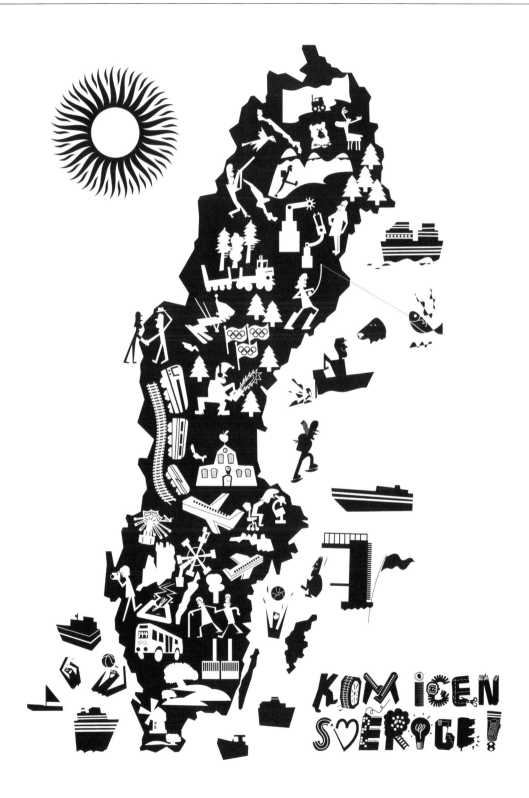

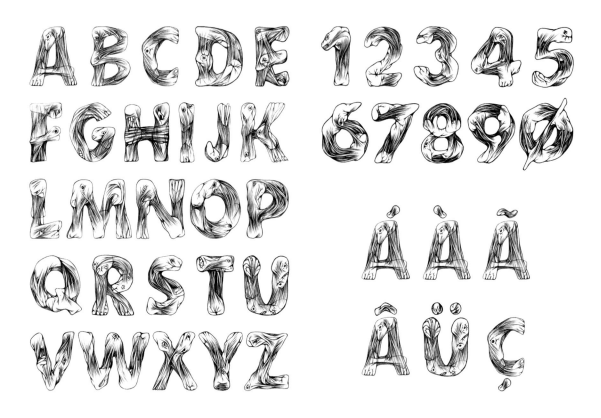

Concept

Freud was inspired by Futura Bold and was developed using organic shapes. This creative universe was a tribute designed to showcase true "surrealist" style.

Contact info

Renato de Carvalho Abreu
rcarvalhohuguenote@yahoo.com.br
www.newspagedesigner.com
Brazil

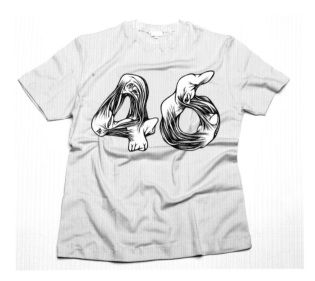

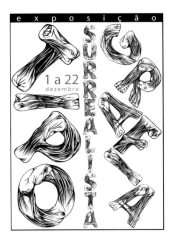

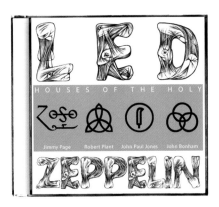

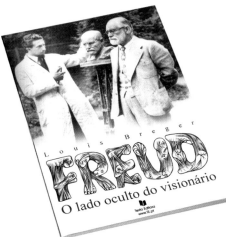

abcdefghijklmn
opqτstuvwxyz
ABCDEFGHIJKLMN
OPRQSTUVWXYZ
1234567890,.:;?!=+¡¿
%éêèëñç$£@&--—
(){}"'°*ÉÊÈËÑ/€©®™

Concept

This font started with the idea of making an "a" and "e" with a slanted line in the middle. As I was trying out different shapes and possibilities, I developed a grid of parallel lines and circles that became the basis for the rest of the font. The letters originally turned out rather straight, but since I wanted them to have a more playful look, I came up with the idea of adding a little serif stroke. Parsimonious use of serifs gives the font an odd but fun feel.

Contact info

Johnny Bekaert
jb@johnnybekaert.be
www.johnnybekaert.be
Belgium

european institute
for cultural studies

onestep@thetime

helpt elkander

coöperatieve vennootschap voor sociale woningbouw

ABCDEFGHIJ
KLMNOPQRS
TUVWXYZ

ABCDEFGHIJKLMNOPQRSTUVWXYZ

Concept

This mosaic-font was designed for a temporary exhibition set in the Bavarian State Archaeological Collection in Munich 2004. The characters were used throughout the parcour in headlines, on posters, on the book cover, etc.

Contact info

Gruppe Gut Gestaltung
Uli Prugger & Alfons Demetz
info@gruppegut.it
www.gruppegut.it
Italy

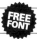

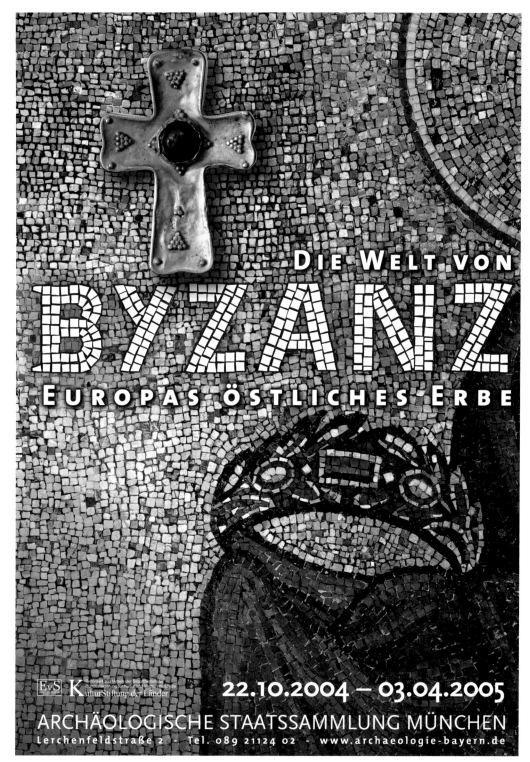

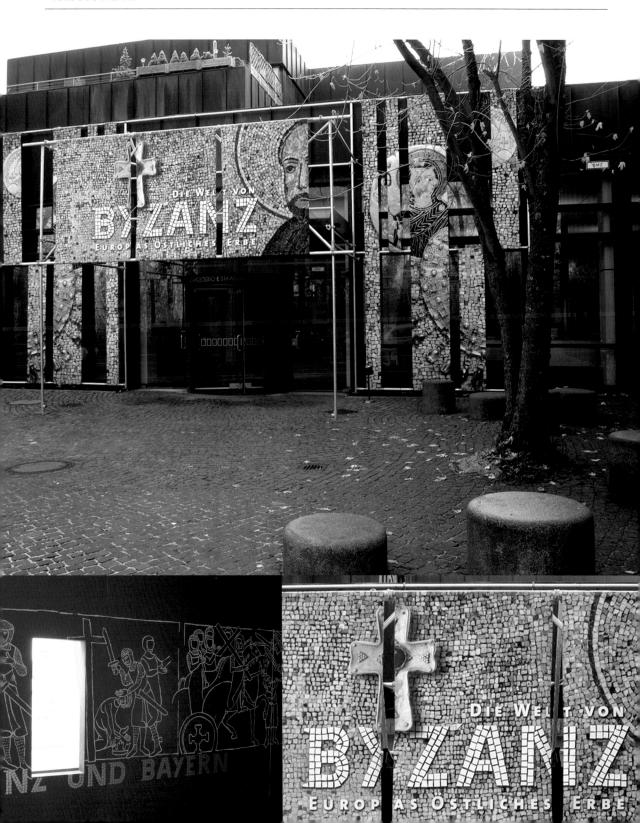

Concept

Glenn's soft, rounded forms were inspired by shoe shop and hairdresser sign typefaces from the 1970s in my hometown, Oporto. Some of these shops are still around today.

Contact info

Miuk
Tiago Pina
tiago@miuk.ws
www.miuk.ws
Portugal

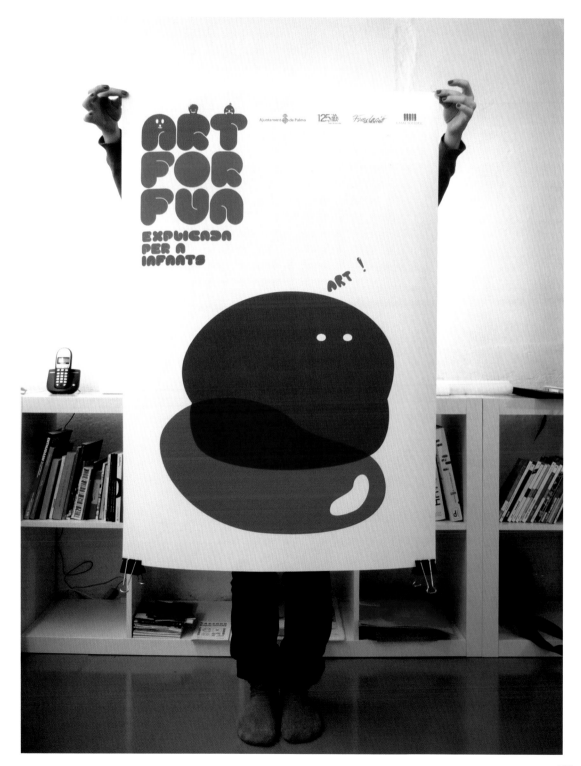

GLENN.
THE NEW MIUK
TYPEFACE

Glenn Typography	Some rights reserved 2008	Incl. 57 characters upper case only	Format: MAC PostScript 1	Free download at: www.miuk.ws
by: Tiago Pina www.miuk.ws info@miuk.ws	Distribution by: www.miuk.ws		Format: MAC TrueType	
			Format: WIN TrueType	

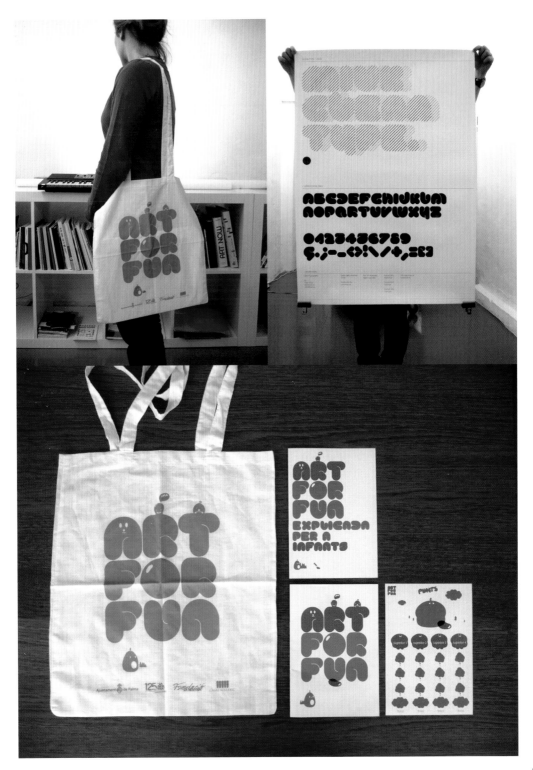

Concept

Globotype consists of 37 dingbats characters created by Pump Diseño. The use of such symbols in Pump Diseño communications prompted us to create a typeface that would make them easier to use. The symbols have symbolic and aesthetic value and belong to the everyday environment, which makes them especially attractive and original.

Contact info

Pump Diseño
estudio@pumpd.com.ar
www.pumpd.com.ar
Argentina

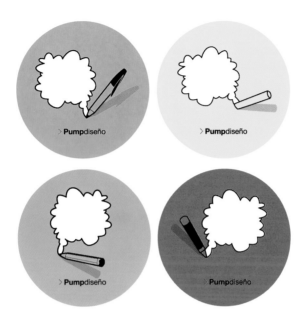

Graffiti Comando 2D

Graffiti Comando 2D (Caps Lock)

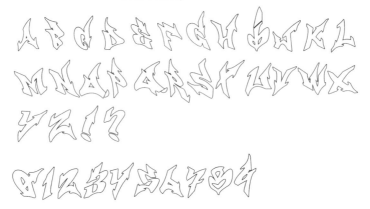

Concept

This font was developed on the basis of research into street design and graffiti, which involve a huge number of fonts and typefaces.

Contact info

Tito Senna
titosenna@gmail.com
www.titosenna.multiply.com
www.fotolog.com/titosenna
Brazil

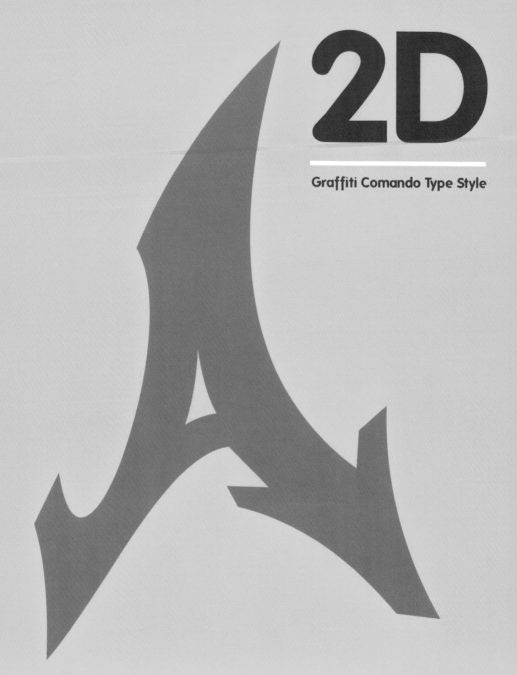

2D

Graffiti Comando Type Style

ABCDEFGHIJKLMN
OPQRSTUVWXYZ
1234567890

ABCDEFGHIJKLMN
OPQRSTUVWXYZ
1234567890

Concept

The fonts Greenland 2008 and 2025 are part of the "Type for Change" project, a platform that uses typography as an agent for positive change.

Contact info

Gustavo Machado Studio
gustavo@gustavo-machado.com
gustavo-machado.com
Canada

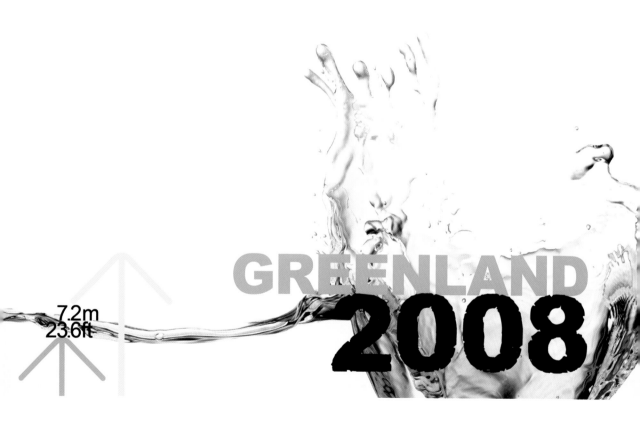

Concept

The fonts Greenland 2050 and 2100 are part of the "Type for Change" project, a platform that uses typography as an agent for positive change.

Contact info

Gustavo Machado Studio
gustavo@gustavo-machado.com
gustavo-machado.com
Canada

ABCDEFGHIJKLM
NOPQRSTUVWXYZ
abcdefghijklmn
opqrstuvwxyzÄöÜ
123456789.,!?-§$/@

ABCDEFGHIJKLM
NOPQRSTUVWXYZ
abcdefghijklmn
opqrstuvwxyzÄöÜ
123456789.,!?-§$/@

ABCDEFGHIJKLM
NOPQRSTUVWXYZ
abcdefghijklmn
opqrstuvwxyzÄöÜ
123456789.,!?-$/@

Concept

Gringo is a font family consisting of 27 different fonts. The family is divided into three groups: Sans, Slab and Tuscan (Europe and Texas). The standard layout of the fonts means that the groups can be mixed at will, and each variant comes in light, medium and bold. Three layers, ranging from narrow to wide, are available. The font family is also rounded out by a new dingbat font. The fusion of all of these elements has created a new font family, breaking barriers to create originality.

Contact info

Magma Brand Design (Volcano Type)
Peter Brugger
www.magmabranddesign.de
www.volcano-type.de
Germany

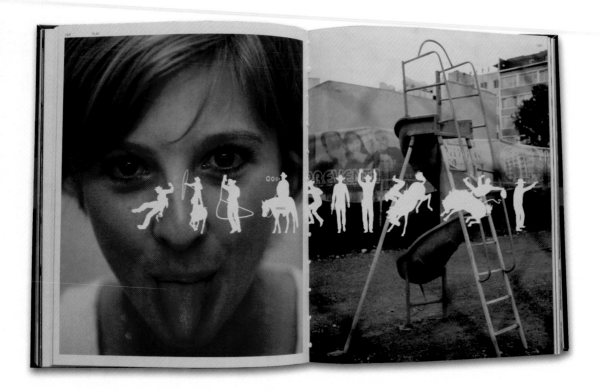

ABCDEFGHIJKL
MNOPQRSTUVWXYZ
abcdefghijklmn
opqrstuvwxyz
0123456789O
(.,!?&$%) éõùß

Concept

This is a special hand-drawn font, but to shake things up, I drew it with my left hand.

Contact info

H2D2 Visual Communications
Markus Remscheid
markus@h2d2.de
www.h2d2.de
Germany

Derkukuk under
esel Di haten
enenStreit
wer wolambesten
sänge zur
schönenMeienzeit

Halo Mami halo
Vati ich bien bei
Marco ich hab
schon geessen und
wahr mit dem Hont
drausen.

Sprache wird
durch Schrift
erst schön.

Willst du mit mir gehen?

Ja ○

Nein ○

Vielleicht ○

ABCDEFGHIJKLM
NOPQRSTUVWXYZ
abcdefghijklmnop
qrstuvwxyz
0123456789O
(.,!?&$%) éõùß

Concept

This font is heavily influenced by Dutch designer Wim Crouwel and is a homage to Gridnik, a font he designed in the 1960s. H2D2 Tape was initially "drawn" with adhesive tape. Afterwards, we scanned the characters and made a digital font out of them. We wanted to give the typeface a rough look to make the origins of the font easily recognizable.

Contact info

H2D2 Visual Communications
Markus Remscheid
markus@h2d2.de
www.h2d2.de
Germany

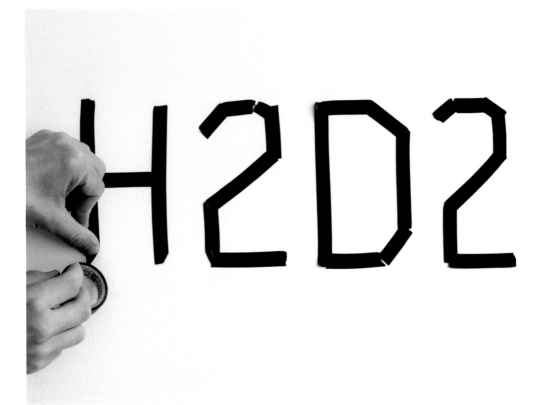

Als eins der ersten Mitglieder
von Underground Resistance hat
Robert Hood Detroit Techno mit
politischen Parolen und radikalen
Klangkonzepten aufgeladen. Seit
den frühen neunziger Jahren geht
er allerdings unbeirrt den Weg
eines Einzelgängers. Vor allem auf
den eigenen Labels M-Plant, Duet
und Drama variiert er immer wie-
der die Hood'sche Idee eines sehr
reduzierten, markanten Techno-
sounds. Mit seinem Album Mini-
mal Nation schrieb er Geschichte –
und schob einen Trend an, der
auch fast 15 Jahre später nicht zu
stoppen scheint. Höchste Zeit, den
Mann mal zu seinen Vorstellungen
von Minimalismus zu befragen.

„Alles beginnt mit einem Rhythmus"

ABCDEFGHIJKLMNOPQRSTUVWXYZ

abcdefghijklmnopqrstuvwxyz

1234567890

!»#$%&()+,,/,©÷

ABCDEFGHIJKLMNOPQRSTUVWXYZ

abcdefghijklmnopqrstuvwxyz

1234567890

!»#$%&()+,/,©÷

Concept

Helvetica Mediterranean is yet another typographic variation of the famous Helvetica font. It was designed for an international poster contest held to commemorate the 50th anniversary (1957–2007) of what is probably the most widely used typeface in history. The motto on the poster said it all: "Helvetica is not typography, it's lettering!", which meant that Helvetica had outgrown itself and become far more than just a typeface, just as the Swiss army knife did. Just like the Swiss knife, in typography, Helvetica can do anything.

Contact info

Studio International
Boris Ljubicic
boris@studio-international.com
www.studio-international.com
Croatia

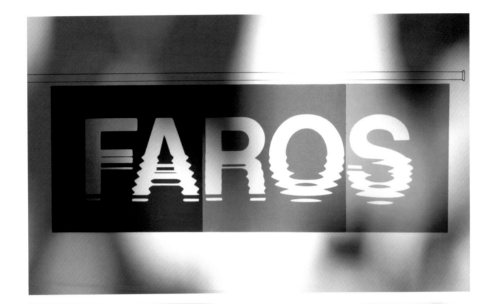

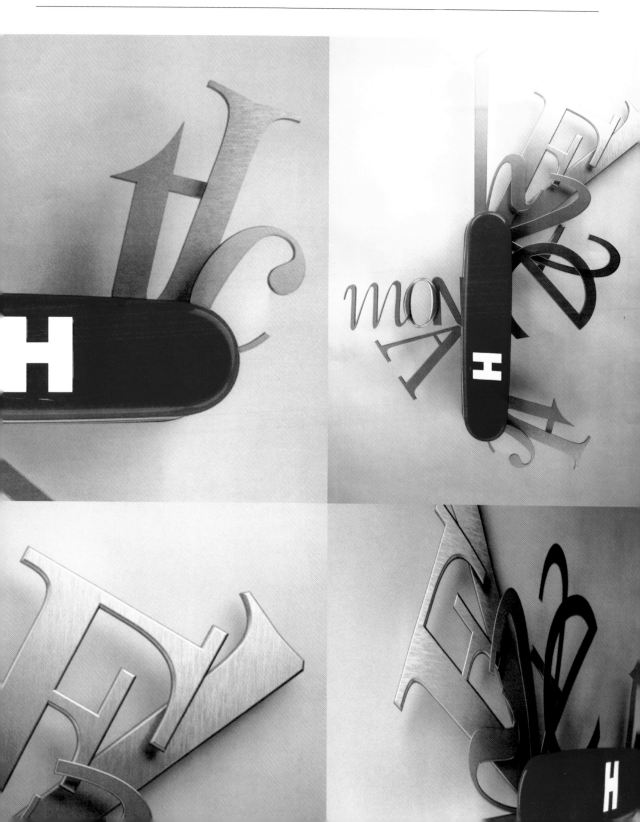

Concept

Brief: Produce a typeface that can exist in three dimensions. Solution: The characters get their form from the holes on the back of the studio chairs.

Contact info

Ben Smith
benkpsmith@hotmail.com
www.ben-smith.com
United Kingdom

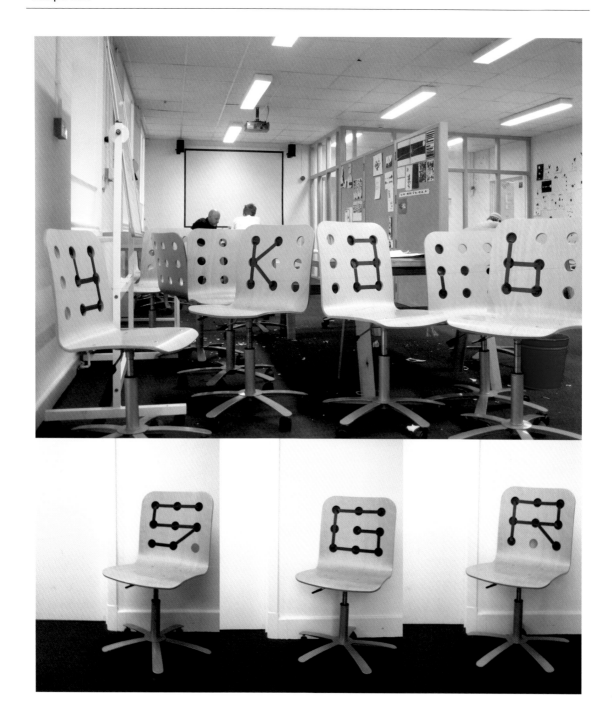

ABCDEFGHIJKLM
NOPQRSTUVWXYZ

abcdefghijklm
nopqrstuvwxyz

1234567890
.,?!() &"ÇÑ çÑ

Concept

This font has regular, italic, bold and italic-bold versions. It should be used in materials relating to technology.

Contact info

Pau Misser
guak@guak.com
www.guak.com
Spain

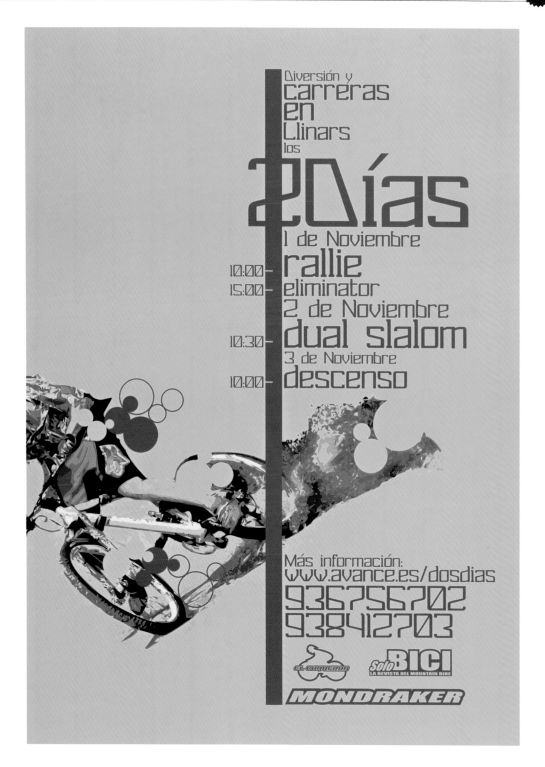

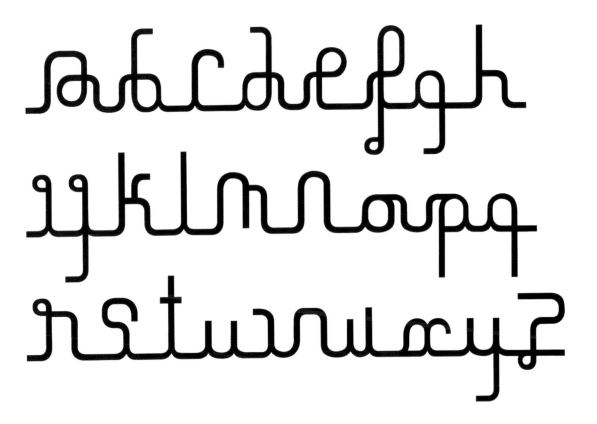

Concept

Here, compound lines are developed into different languages, each maintaining their own specific scripts.

Contact info

Daphne Heemskerk
info@daphneheemskerk.com
www.daphneheemskerk.com
The Netherlands

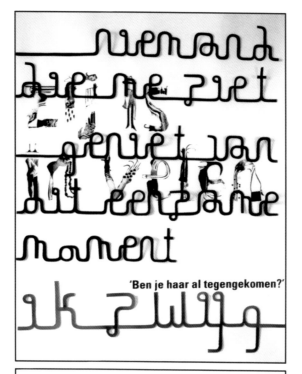

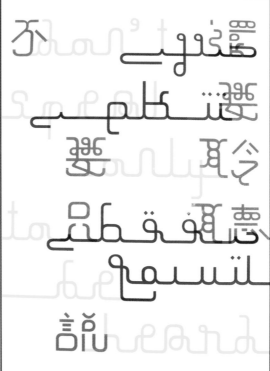

ABCDEFGHIJKLMN
OPQRSTUVWXYZ

abcdefghijklmnopqrstuvwxyz

1234567890
.,;-_:/?!

Concept

This typeface was created for use at extreme sports events or in extreme sports stores or magazines.

Contact info

Pau Misser
guak@guak.com
www.guak.com
Spain

VEN A CORRER ↓↓↓

1 de Noviembre
Pedalada "EL CORREDOR"
-8.00 a 9.00 Inscripciones
-9.30 Pedalada

Dual Slalom "GUAK"
-8.00 a 10.00 Inscripciones
-9.00 a 10.30 Entrenos
-11.00 Dual Slalom

2 de Noviembre
Descenso "MONDRAKER"
-8.00 a 9.30 Inscripciones
-10.00 Descenso

Llinars del Valles (Barcelona) Dias 1 y 2 de Noviembre
Info: 938412703-936756702

www.guak.com/dosdias

189

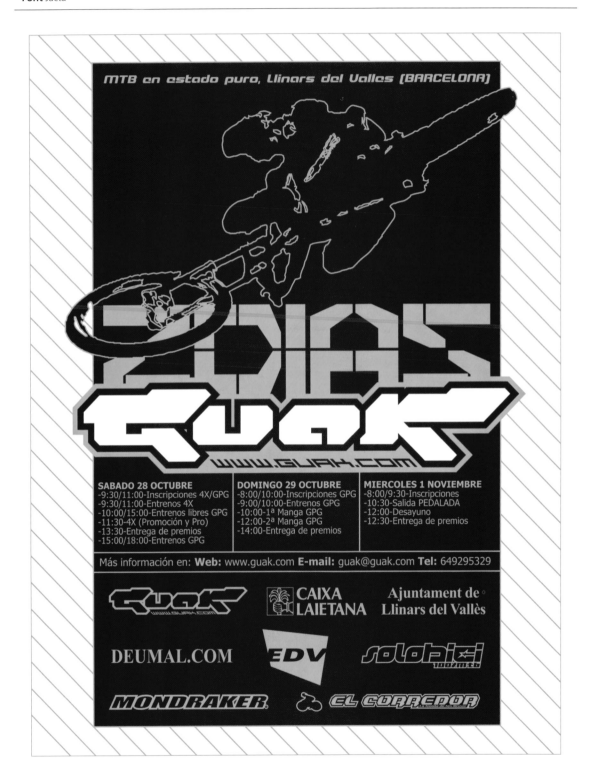

ABCDEFGHIJKLM
NÑOPQRSTUVWXYZ

abcdefghijklmnñop
qrstuvwxyz

1234567890!i:;.,·#$"@&_
()=*¿?´[]-{}<>§£¥©®ØÇ/\

Concept

Kool 1988 is a font that can be very powerful when used carefully. It is best used with images.

Contact info

Andrés Sentis
tioass@hotmail.com
www.andressentis.com.ar
Argentina

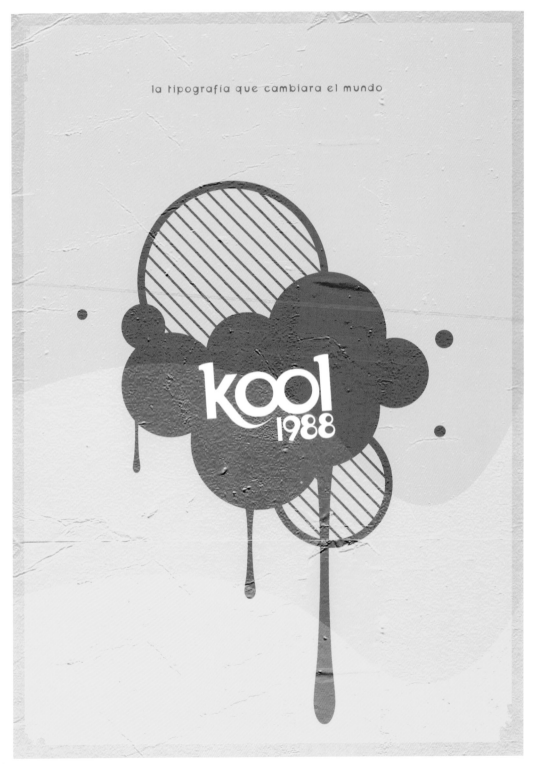

Actitud tipográfica al servicio del lienzo universal. Tan pregnante como para tatuársela y a su vez tan sutil como para escribir las mas bellas poesías de amor. No es solo otra tonta tipografía, es Kool 1988

Lorem ipsum dolor sit amet, consectetuer adipiscing elit. Integer lacinia orci. Cras ad nunc sed lectus tincidunt accumsan. Aliquam cursus nisl id nisl. Praesent fermentum ligula at nisl. Cras posuere nulla adipiscing erat. Sed tristique, metus sed sagittis adipiscing, tortor mi facilisis lorem, nec porta felis neque at ligula. Suspendisse potenti. Pellentesque vitae ipsum eget nulla placerat porta. Aliquam erat volutpat. Cum sociis natoque penatibus et magnis dis parturient montes, nascetur ridiculus mus. Pellentesque malesuada, ipsum non malesuada sollicitudin, metus leo elementum magna, a gravida felis ipsum et orci. Sed nunc. Vivamus ut nulla. Maecenas et velit sed lacus imperdiet adipiscing. Nunc rutrum lectus adipiscing magna. Duis vitae est. Vivamus neque. Maecenas ac enim. Suspendisse potenti. Aliquam vel odio. Curabitur tempor egestas lectus. Fusce vehicula, velit quis tristique pellentesque, ligula lacus accumsan lacus, accumsan luctus augue odio non tellus. Aliquam felis leo, accumsan ut, cursus vel, malesuada quis, neque. Donec sodales pharetra nulla. Pellentesque aliquet ullamcorper lectus. Donec commodo pretium metus. Integer a nisi ut dui elementum gravida. Pellentesque mauris. Aenean laoreet. Aliquam interdum massa quis metus. Nulla ultrices. Nullam elementum. Integer convallis bibendum erat. Quisque risus. Morbi odio. Praesent ipsum lacus, gravida et, elementum quis, accumsan nec, justo. Nullam convallis eros eget velit luctus consectetuer. Vivamus est. Nullam sagittis sem rutrum orci. Suspendisse potenti. Etiam a libero. Duis gravida pharetra risus. Mauris mollis venenatis tellus. Vivamus vulputate est at nibh. Quisque fermentum orci. Sed metus nunc, luctus quis, tempor et, laoreet vitae, risus. Fusce vitae neque. Sed quis ante. Vivamus lacus. Vivamus sit amet augue quis leo sagittis viverra. Aliquam enim sapien, scelerisque a, tempor vitae, scelerisque id, lacus. Morbi mollis. Nulla sed nisl eu elit vestibulum blandit. Morbi malesuada justo eget lectus. Mauris iaculis elit quis justo. Vivamus sit amet augue quis leo sagittis viverra. Aliquam enim sapien, scelerisque a, tempor vitae, scelerisque id, lacus. Morbi mollis. Nulla sed nisl eu elit vestibulum blandit. Morbi malesuada justo eget lectus. Mauris iaculis elit quis justo. Suspendisse potenti. Aliquam vel odio. Curabitur tempor egestas lectus. Fusce vehicula, velit quis tristique pellentesque, ligula lacus accumsan lacus, accumsan luctus augue odio non tellus. Aliquam felis leo, accumsan ut, cursus vel, malesuada quis, neque. Donec sodales pharetra nulla. Pellentesque aliquet ullamcorper lectus. Donec commodo pretium metus. Integer a nisi ut dui elementum gravida. Pellentesque sodales mauris. Vivamus cursus soda lesua est.

Hermosos paisajes fantásticos al alcance de cualquiera que desee visitarlos. Es el sur Argentino, una reserva de magia natural, un pequeño paraíso dentro de un mundo tan viciado. Kool 1988 nace de la magia de este recóndito lugar.

ABCDEFGHIJKLM
NOPQRSTUVXYwZ

abcdefGHijklm
nopqrstuvxywz

01234567890

#"""

Concept

Kuy Digital is a personal font.

Contact info

Kuy Digital
Oliver Kuy
kuydigital@gmail.com
www.kuydigital.com
The Philippines

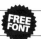

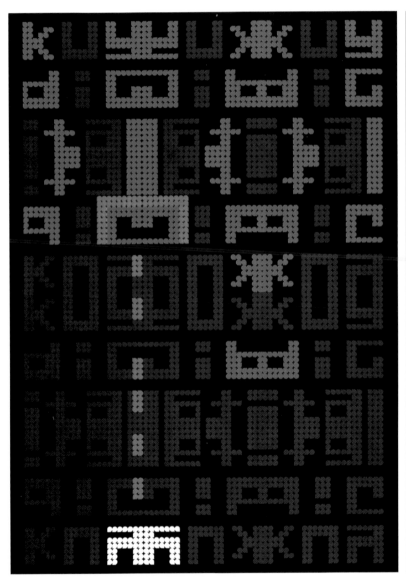

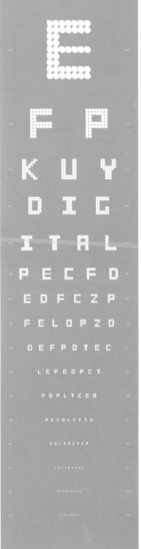

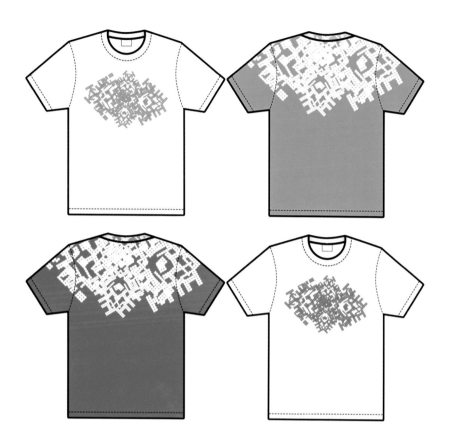

Concept

Religions are full of signs and symbols. Some like the star of David and the swastika received other connotations during the Third Reich. The matrix for this font was created by superimposing these two symbols on top of each other. Machtwerk is a font that critically questions and recalls the darkest chapter of German history.

Contact info

Magma Brand Design (Volcano Type)
Patrick Hubbuch
www.magmabranddesign.de
www.volcano-type.de
Germany

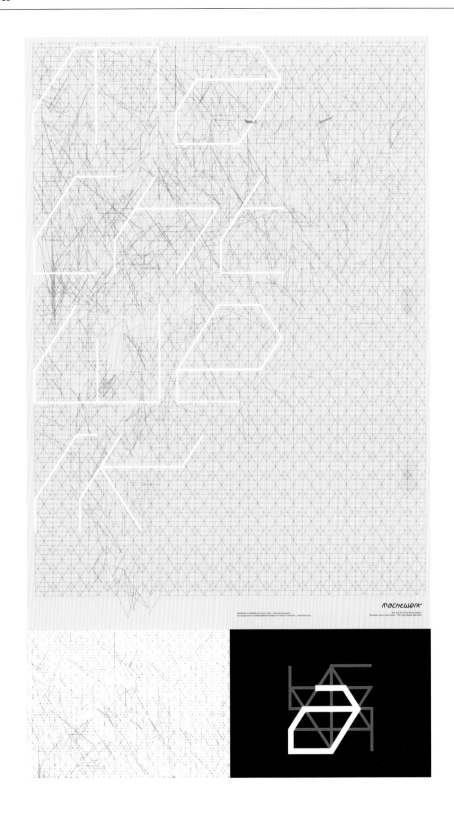

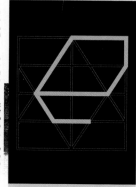

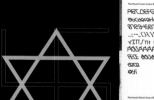

ABCDEFGJ+®
HIJKLLMNè?"
ÑOPQRSTUIX
UWXYZ$/;"ЇЄ
1234567890

Concept

A typeface with personality that is best used for display type or just caps.

Contact info

OrtizDzn
© Jose Luis Ortiz Tellez
joseluisortiz2@aol.com
United States

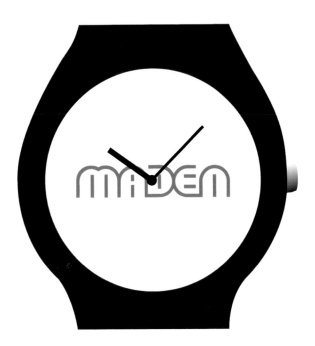

Concept

Manifesta was drawn at Atelier Roosje Klap by Antoine Bertaudière and was designed especially for an exhibition at Manifesta 2008.

Contact info

Atelier Roosje Klap
studio@roosjeklap.com
www.roosjeklap.com
The Netherlands

The program **Matter of Fact** explores educational aesthetics in performativity. Questioning the transmission of subject matter, knowledge and content, the performer implies pedagogical methods when speculating on the formality of artistic, fictitious and personal politics of history. A small 'cast' of contributors are using the timeframe of the exhibition as a point of departure to reflect upon their own method of transcending knowledge. Their specificities range from the pure formality of the conscious, language as a visual spectacle, mediators of cultural production and epic emancipators of utopian (political) potentialities.
The program is structured and controlled from the Manifattura Tabacchi venue and functions as part of the overall exhibition. This space takes on an active and fluxuating form of an office, information point and an 'exhibition space' where rehearsals, performances, talks and screenings take place within a permanently designed structure. Each of the contributors will present/perform within this structure and revisit their previous presence by returning frequently during the course of the exhibition. In this way they will educate and reflect upon themselves in a performative way.

MATTER OF FACT
19/07 – 02/11/08
MANIFESTA7

Location
Manifattura Tabacchi
Rovereto, Italy

Artists
Jeremiah Day
Renzo Martens
Olaf Nicolai
Adam Pendleton
Falke Pisano/Will Holder
Ricardo Valentim

Curator
Krist Gruijthuijsen

Matter of Fact is part of
Principle Hope, Manifesta 7

Program

Ricardo Valentim
Film Festival (from 2007 on): 3 screenings per day
(content program displayed within the space)
A form of display (2008), wall drawing throughout
the Manifattura Tabacchi building

Olaf Nicolai
Instructions how to produce a site specific work anywhere
(from 2001 on)
16/07 – 21/07/08
Presentation: 09/09 15:00

Renzo Martens
(Fragment of) **Episode 3** (2008) permanently on display
15/10 – 17/10 (program to be announced)

Adam Pendleton
Opening days Manifesta 7:
17/07 11:00 **BLACK DADA: A History of Art**
20/07 15:00 **BLACK DADA: A History of Art**
06/08 – 10/08 (program to be announced)

Jeremiah Day
Opening days Manifesta 7:
19/07 13:00 **Smoke Clears, Dust Settles**
03/09 – 07/09 (program to be announced)

Falke Pisano/Will Holder
Opening days Manifesta 7:
19/07 15:00 **Wo Ich die Erde am schönsten fand**
17/09 – 21/09 (program to be announced)

The presentations are a combination of scheduled, permanent and spontaneous events mentioned on daily updated schedule specifying its content. The schedule is displayed within the space.

The program **Matter of Fact** explores educational aesthetics in performativity. Questioning the transmission of subject matter, knowledge and content, the performer implies pedagogical methods when speculating on the formality of artistic, factitous and personal politics of history. A small cast of contributors are using the timeframe of the exhibition as a point of departure to reflect upon their own method of transcending knowledge. Their specificities range from the pure formality of the conscious, language as a visual spectacle, mediations of cultural production and epic emancipations of utopian (political) potentialities.

The program is structured and controlled from the Manifattura Tabacchi venue and functions as part of the overall exhibition. This space takes on an active and fluxuating form of an office, information point and an exhibition space: where rehearsals, performances, talks and screenings take place within a permanently designed structure. Each of the contributions will present/perform within this structure and revisit their previous presence during the course of the exhibition. In this way they will educate and reflect upon themselves in a performative way.

MATTER OF FACT
19/07 – 02/11/08
MANIFESTA7

Location
Manifattura Tabacchi
Rovereto, Italy

Artists
Jeremiah Day
Renzo Martens
Olaf Nicolai
Adam Pendleton
Falke Pisano/Will Holder
Ricardo Valentim

Curator
Krist Gruijthuijsen

Matter of Fact is part of
Principle Hope, Manifesta 7

Adam Pendleton

Adam Pendleton is a painter, writer and performer who uses extreme freedom of reference and quotation, as well as a rejection of conventional hierarchies among sources, to create a re-historicized present, one that upsets and unbalances comfortably subjective interpretations of history and culture. Pendleton's conceptual practice consists of formal temporizations into which he slots information. His allacements obey predetermined rules of composition depending on the series. Two-color text paintings, (the font a standardized Arial bold), or three-color text and ephemera, or words and letters taken from culture using formally-specified long-range procedures. The displacement of authorship and underlying political-aesthetic vision of the work builds signification through a process of repetition and accumulation.

For Performa 07, Pendleton produced **The Re-vival** – a fusing together of the disjunctive genres of Southern-style religious revivals (including a 30-person Gospel choir) and avant-garde language practices. Pendleton's *sermon*, stream of an uncommon language, invoked the power of experimental language to subvert everyday discourse. Composed of unattributed fragments taken from sources such as activist and playwright Larry Kramer and the progressive poets John Ashbery, Harryette Mullen and Paolo Javier, the work combined the manipulative force of a revival with radically secular language and rhetoric.

As his contribution to the biennial, Pendleton will deliver **A Black Dada Manifesto**. The manifesto(s) will be an assimilation of unattributed source material compiled from existing manifestos and other texts (including the artists own), which extend from the Dadaists to today. The manifesto(s) will change in response to texts, films and sound work the artist will make available on site.

Adam Pendleton was born in Richmond, Virginia and is based in New York. He has exhibited extensively throughout the US, notably at the Museum of Contemporary Art, Chicago; the Indianapolis Museum of Contemporary Art; the Contemporary Arts Museum, Houston; the Studio Museum in Harlem; and the Whitney Museum of American Art. This summer his work will be exhibited at the Stedelijk Museum in Amsterdam, the Deutsche Guggenheim in Berlin and the High Museum of Art, Atlanta. Recent New York performances include **Performa 07** and **Creative Time's Hey Hey Glossolalia**. Pendleton is co-editor of **LAB MAG**.

Ricardo Valentim

The artistic practice of Ricardo Valentim systematically uses, as a true dilletante, by redefining the construction of established cultural forms. Using these references as a point of departure, the artist explores a variety of themes, structures, of social reality and mostly of the mediated use of recreation spaces where we interact. Valentim's practice comprises of a two-month series of screenings featuring seventy educational films produced for educational programs at the North American schools and television channels between the 1950s and 1980s. The films were originally commissioned from various agencies including advertisement firms, tourist boards, various universities, United Nations, US Department of Education and others. **Film Festival** emphasizes on the ways in which education was developed within specific references and framed to a particular view of the world. It therefore questions the construction and usage of the artist and discloses the mechanisms of cultural production by reflecting upon the identity of the dominant group that, through different practices of representation, defines the general pattern of culture and establishes the regulation of social conduct. Valentim compiled an overarching program with several sub programs that, through the relationships between all the films, deconstructs its original context. It's not meant to be seen as found footage

or as representational exploitations of Folklore but rather as an intention to suggest connections and communalities created by the program's juxtaposition and to introduce new and more ethical approaches regarding the same content.

Film Festival will screen daily at various forums and its complete program can be be found within the specially designed brochure displayed within the space.

Next to Film Festival, Valentim designed a wall drawing throughout the Manifattura Tabacchi building entitled **A form of display**.

Ricardo Valentim (born 1978 in Loulé, lives in New York) studied anthropology at the Universidade Lusófona de Humanidades e Tecnologias, Lisbon and visual arts at the School of Visual Arts, New York. His exhibitions include **Film Festival** at e-flux or untitledmanœuvre, New York (2006), Contrabando curated by Carolina Grau (at Luísa Strina Gallery, São Paulo (2006) and **Art Statements** at ArtBasel38, Basel (2007). Valentim has recently started a new series of works comprised of lectures including **Growth and Culture** at Galeria Pedro Cera, Lisbon (2008).

Renzo Martens

Renzo Martens' practice aims to investigate and provoke the indoctrinated imagery of travesties as preserved by the western media.

As a troubadour of sorts, Martens' ventures through the chaotic landscapes that we, as consumers of tragedy, appear to be familiar with. It is, in fact, this familiarity that Martens is interested in. He metaphorically identifies himself as an example of western spoiled mentality by bluntly placing himself within the direct conditions as broadcasted on television. Episode 1, his debut film, is a journey through the landscape of a demolished and oppressed Chechnya. Wandering through refugee camps, Martens reverses the role of the interviewer, one that normally documents refugees and UN employees on their current state, into a pathetic love story of a young man: heartbroken and in desperate need for attention.

This way, it is Martens himself who becomes objectified rather than the all too familiar imagery surrounding him. These highly inappropriate interviews generate a strong feeling of discomfort and exasperation. Yet it is precisely this awkwardness that renders his egocentric and spoiled behaviour sincere, non while simultaneously becoming the economy of media consumption becoming an eclectic and therapeutical entity.

Continuing his journey of the world as a spectator's paradise, Martens has been investigating Africa, and in particular Congo, as potentially most lucrative

export product. Images of poverty. Episode 3 reveals in a direct, confrontational but at the same time naive way Congo's possibilities of exploiting their own poverty in addition to its usual exports such a rubber or cocoa. The disturbing imagery of the local tragedy are typically utilized by the West as beneficial profits while locally nothing positively evolves.

Martens' attempts to liberate the Congolese from this vicious circle by presenting himself as a 'savior' who educates the inhabitants to benefit from their own poverty. This utopian gesture leads to an epic expedition of true revelation in which Martens, as always, appears to be the core of subject matter.

For Manifesta 7, Martens will present a study material of Episode 3, which are to be seen as representational products addressing several issues within the project. These insert(s) are permanently on view within the space and will be accompanied by several lectures of Martens himself.

Renzo Martens was born in 1973, Sluiskil, The Netherlands. He lives and works in Brussels, Amsterdam and Kinshasa. Recent exhibitions include A Picture of War is not War, Wilkinson Gallery, London (2006); Soft Target Basis Aktuelle Kunst, Utrecht (2005); Nothing Else Matters. De Hallen, Haarlem, The Netherlands (2007); To Burn oneself with oneself: the romantic damage show. De Appel, Amsterdam (2008). He will have a solo show at the Stedelijk Museum Bureau Amsterdam in the fall of 2008.

Jeremiah Day

In Jeremiah Day's work personal histories intermix and sometimes coincidentally connect political events, forming an experimental and open-ended historiography.

In his performances he often uses slide projections, music and singing in which he pedagogically transmits subject matter by taking a personal stand on the format of lecturing. Recent topic he has been addressing in his work are the reconstructions of the Vietnam Veteran's Memorial in Washington in the summer of 2004 (1,2,3,4), the complete evacuation of the people of the Blasket Islands off the Dingle Peninsula (Ireland) to the town of Springfield near Boston (USA) in the 1950s (News animations/No words for you Springfield) and the historic New England landscape and recent political episode and recent political situation of its native population, which delved into the concrete and poetic legacy of the French Resistance, as well as making new movement-speaking improvisations. Day will present some of his on-going research into Berlin as a site

of intersection between local and world history, and touch upon the unique history of northern Italy's Autonomia movement.

Jeremiah Day (1974, USA) lives and works between Amsterdam and Berlin. He is a graduate of the University of California at Los Angeles Fine Arts Department, and in 2002/2004 he was a participant at the Rijksakademie Amsterdam. Recent Exhibitions include We All Loughed At Christopher Columbus, Stedelijk Museum Bureau Amsterdam and Platform Garanti, Istanbul. The fall of the Twelve Acres Museum, Ellen de Buijne Projects (solo) and the historic New England landscape and recent political situation, which delved into the concrete and poetic legacy of the French Resistance Indians (The fall of the Twelve Acres Museum).

For his contribution to program Jeremiah Day will present a series of performances integrating slide shows, reading and music.

Falke Pisano

The research and work of Falke Pisano analyzes the possibilities of structure embedded in the abstraction between language and objects. In her production, specific core elements are reappearing. These elements, such as using language as an object or as a possibility to construct one, the flexibility of concrete material in language or the relationship of the structure of an object towards performativity, seem for her still unresolved and are therefore taken into a highly personalized account in which she tries to avoid narrative structures, symbols, metaphors and interpretations without deconstructing and facing its problems.

She defines the construction of an (abstract) object by using a speculative language to replace its actual presence. Therefore, she introduces another state of existence by exploring the possibilities of remodelling the (objective) structure. From observing an object (concrete abstractions), manipulating the object (A sculpture turning into conversation), positioning its creator within the tautological object (affecting abstraction) to finally disintegrating the object (Object and disintegration: The Object of Three.) This procedure is altered into performances, videos, objects and publications where often the perspective of the author enables the act to transform into a fragile performative observation.

Currently, she's preparing a publication together with Will Holder, which emphasizes her process on the spectacle of the object (as mentioned earlier). For Manifesta 7, a specific core element are reappearing. These events, such as using language as an object will be presenting a series of 'performative' discussions/interviews together with Will Holder that forms the content of the publication, which will be presented by the end of the exhibition.

Falke Pisano was born in 1978 in Amsterdam, Netherlands. Recent solo exhibitions include Dolce-Henting, Paris (2008), and Ellen de Buijne Projects, Amsterdam (2007). Recent group exhibitions include Of this role I cannot guarantee a single word no shadow, 5th Berlin Biennial for contemporary art, Berlin (2008); Imagine Action, Lisson Gallery, London (2007).

Olaf Nicolai

Olaf Nicolai's Instructions how to produce a site specific work anywhere was initiated in 2001 and is ongoing ever since. For its realization, the curator casts a 'doppelgänger' of the artist and organizes his several-day sojourn at the location of the project. The selected person keeps a diary; this material is later constructed as the diary of the artist. The book will appear in the respective language accompanying the earlier produced volumes (Vienna, 2004; Varna, 2005 and Munich in 2005) therefore stressing the project's continuity.

Will Holder's preoccupation lies within scripting and documenting the relationship between language production (in particular the three-dimensionality of speech and conversation) and the production of objects. Holder is the editor (with Dieter Roelstraete and Ann Demeester) of FR DAVID; de Appel's journal concerned with reading and writing in the arts. He is currently rewriting William Morris News from Nowhere (An epoch of rest) (1876) into a guide for design education and practice set in 2105.

Olaf Nicolai studied at the School of Applied Arts, Schneeberg, and German Literature and Philology at the Universities of Leipzig, Budapest and Vienna. In 1992, he completed his PhD on the Vienna Group. He has been awarded several grants, including the Studienstiftung des Deutschen Volkes or the Studies Centre for Art and Science in Venice, 1993, Villa Massimo, Rome, 1996; the P.S.1 Museum Grant, New York, 1998; the IASPIS Grant, Stockholm, 2000; the Art Award Wolfsburg, 2002 and the Villa Aurora, Los Angeles, 2008. He has participated in numerous exhibitions, such as documenta X, 1997; Venice Biennale, 2001 and 2005, Sydney Biennial, 2002; Gwangju Biennial, 2002; Sharjah Biennial, 2005; Athens Biennial, 2007, and his work is shown in institutions worldwide (Migros Museum, Zürich; Museo Serralves, Porto; Museum of Modern Art, New York; Fondation Cartier, Paris; Lenbachhaus, Munich). He lives and works in Berlin.

Manifesta 7. The European Biennial for Contemporary Art
Trentino – South Tyrol, Italy
19/07 – 02/11/08
www.manifesta7.it

Artists: Jeremiah Day, Renzo Martens, Olaf Nicolai, Adam Pendleton, Falke Pisano/Will Holder, Ricardo Valentim
Curator: Krist Gruijthuijsen
Text: Krist Gruijthuijsen
Design: Studio Raoise Klop, Amsterdam (Roosje Klop with Antoine Dertaudère and Angeline Ostinelli)
Typeface: TTC Serif by Herb Lubalin and Antonio DeSpigna, 'Manifesta' by Antoine Dertaudère
Edition: 5000 copies

Matter of Fact is part of **Principle Hope** curated by Adam Budak. Generously supported by **Fonds BKVB, The Netherlands**. Direção-Geral das Artes / Ministério da Cultura, Fundação Calouste Gulbenkian e Fundação Luso-Americana

MAN**IFESTA**7

abcdefghijklmnñopqrstuvwxyz

ABCDEFGHIJKLMNÑOPQR
STUVWXYZ
1234567890

Concept

A classic, innocent, fun typeface that can be used for ads, TV shows and anything else related to gastronomy.

Contact info

Pelayo Romero
pelayoayo@hotmail.com
www.pyostudio.es
Spain

Tenemos los mejores productos
Azucar, Pomelo, Tapas

CERILLAS

Cocktails, Cafés, Tés. Infusiones, Posavasos, Azúcar Moreno, Aceitunas, Caña de Lomo, Cerveza, Vino tinto, Rueda,

SEÑORAS - CABALLEROS - PRIVADO

Rock & Roll, Piña Colada

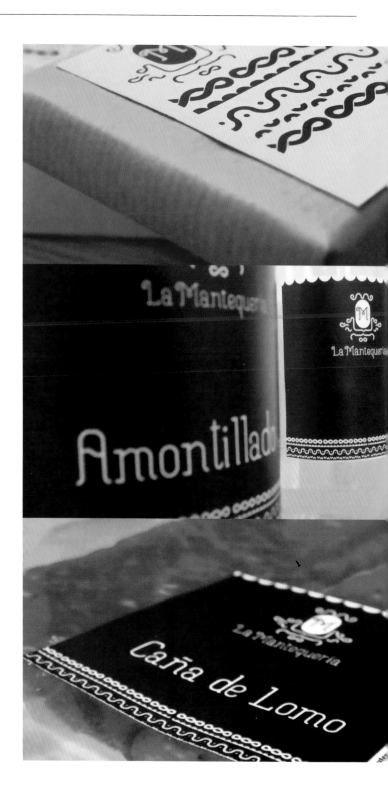

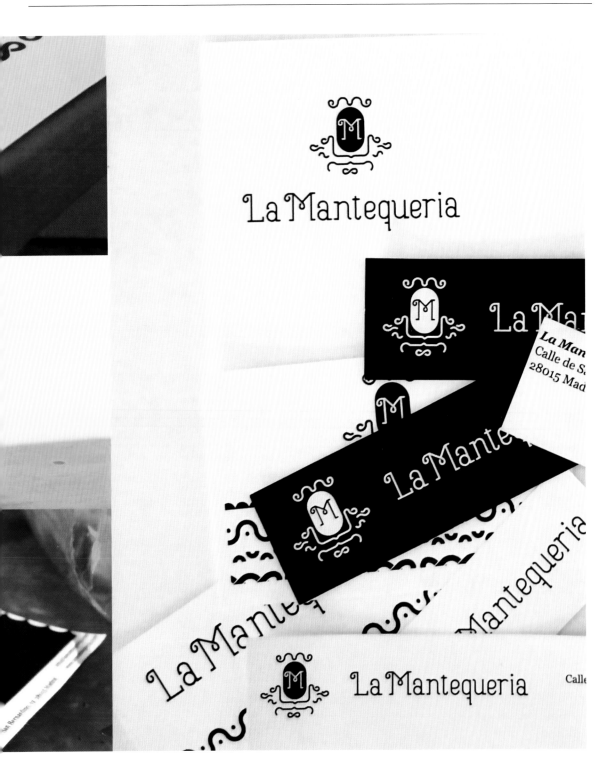

a b c d e f g h i j k l m n

ñ o p q r s t u v w x y z

1 2 3 4 5 6 7 8 9 0

. , : ; - _ ¡ ! ¿ ? () [] / \

° ª ” # $ % & ç = ` ´ ¨ ^ ❖ ‹ ›

Concept

This typeface was developed as the fusion between two completely different styles: a serif font and a Gothic font. We identified the main forms of each and used them to give life to this new modern Gothic and much more usable style.

Contact info

G:lou Creatividad
Mario García Loureiro
g.lou.creatividad@gmail.com
www.gloucreatividad.es
Spain

ABCDEFGHIJKLM NOPQRSTUVWXYZ abcdefghijklmnopqrst uvwxyz.fifl";-?¿$&*·§¶» áàâäåñç@! (0123456789} ɛic̄tɔhffgiîpîr̂itsiste‿a

Concept

Family: regular, italic, bold, bold italic and extra (special characters). This typeface was designed and produced exclusively for the trend magazine *2punts*. Nowadays, the font is used to give shape to all of the magazine's headers, leaders, etc., and the special characters are used to emphasize and give graphic hierarchy to the publication.

Contact info

Dúctil
Damià Rotger Miró
ductil@ductilct.com
www.ductilct.com
Spain

ginebra mítica charjnge
Mangueras fiestas cocina

ACDHIJKLMN
OPSTUZ
abcdefhijklmnopq
rstuvwxyzáôñçü

Entijans
Rancord
manehu

Ferreries Menorca

2360, Mitjana

Arquitectura Disseny Gràfic

adimhnoqru

abcdefghijklmn

opqrstuvwxyz

0123456789

?!(){}[]&@.,:;-—><+×÷

Concept

Based on Universal, which was designed by Herbert Bayer in 1925, New Bauhaus is a clean, geometrical type for display use.

Contact info

Bruno Pimenta
brunopimenta@gmail.com
www.brunopimenta.com
Brazil

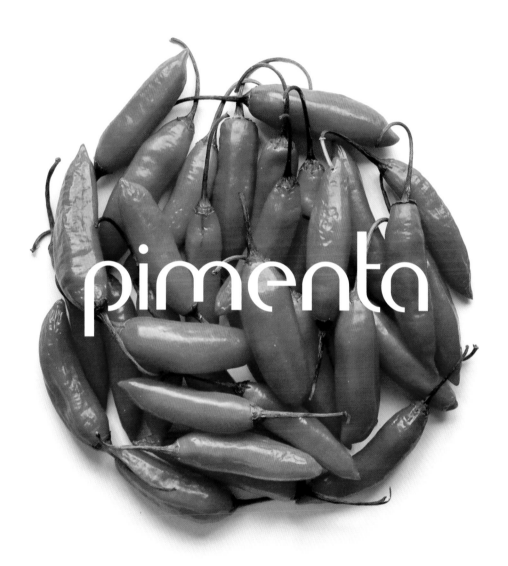

design+fotografia

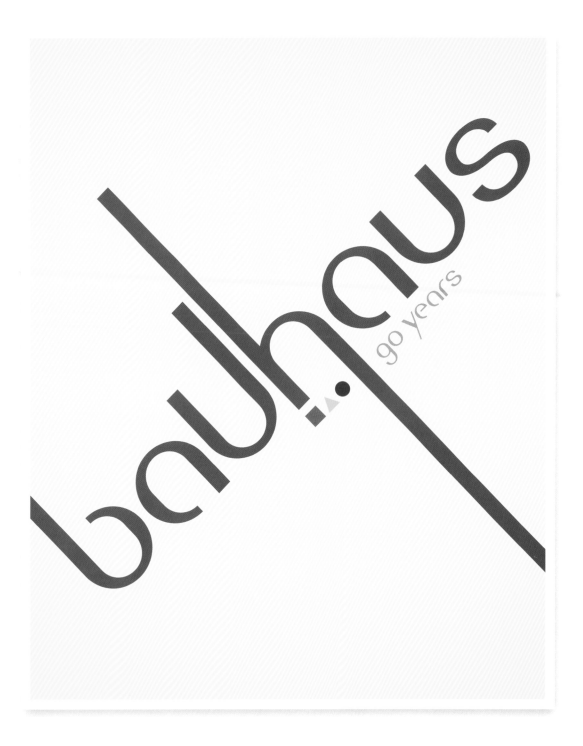

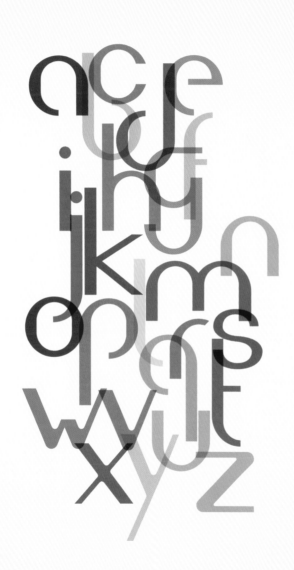

new bauhaus

abcdefghijklm nopqrstuvwxyz

ABCDEFGHIJKLM NOPQRSTUVWXYZ

« 0123456789 »

[({^`¨¯´ ˛˜° ˇ”~*.,:;…"'„‖†‡ˆ‹'""•_–—˜›})]
àáâãäåæçèéêëìíîïòóôõöøúùûüýÿ
ÀÁÂÃÄÅÆÇÈÉÊËÌÍÎÏÑÒÓÔÕÖØÙÚÛÜÝŸ
ªº123™#©$¢ß€£¥þ ¤µ¡!¿?/\‰%‹›«»#&€§@¶-+±÷=¬<>

Concept

Ninfa started out as a simple drawing on a piece of paper. Later, it was modeled on a computer and a number of calligraphy elements were added. The step-by-step development of Ninfa's forms is showcased on the dootype website.

Contact info

Eduilson Wessler Coan
doo@doodesign.com.br
www.dootype.com.br
Brazil

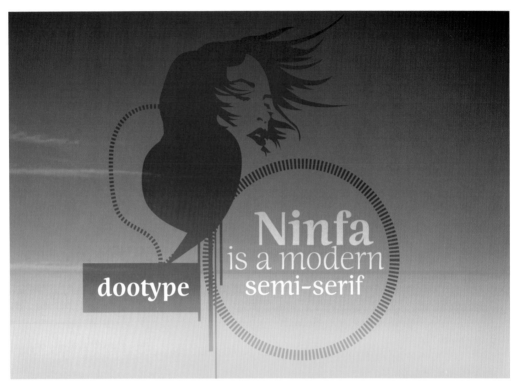

ABCDEFGHIJKLMNÑ
OPQRSTUVWXYZ

abcdefghijklmnñop
qrstuvwxyz

0123456789

ÁÉÍÓÚÄËÏÖÜÀÈÌÒÙ
áéíóúäëïöüàèìòù

! % [=] { ? } - [] . , : ;

Concept

A Gothic font with a textured style.

Contact info

256 Colores
Axel Leyer Amorós
axel@256colores.net
www.256colores.net
Spain

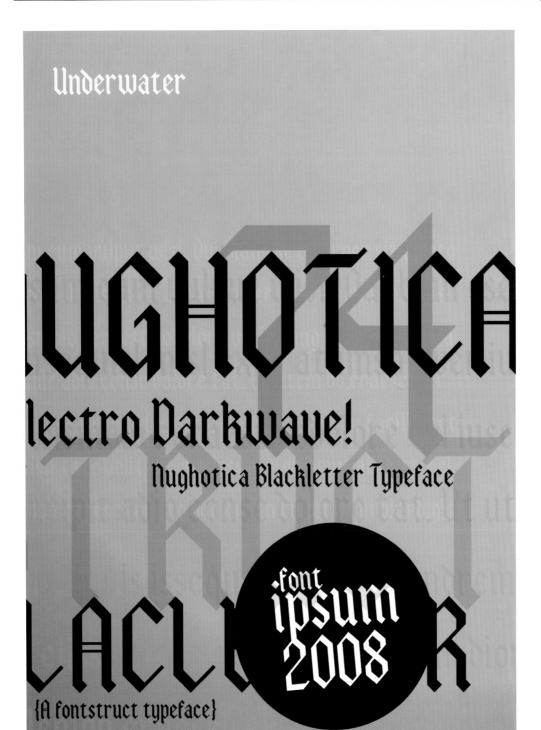

En un lugar de la Mancha, de cuyo nombre no quiero acordarme, no ha mucho tiempo que vivía un hidalgo de los de lanza en astillero, adarga antigua, rocín flaco y galgo corredor. Una olla de algo más vaca que carnero, salpicón las más noches, duelos y quebrantos los sábados, lentejas los viernes, algún palomino de añadidura los domingos, consumían las tres partes de su hacienda. El resto della concluían sayo de velarte, calzas de velludo para las fiestas con sus pantuflos de lo mismo, los días de entre semana se honraba con su vellorí de lo más fino. Tenía en su casa una ama que pasaba de los cuarenta, y una sobrina que no llegaba a los veinte, y un mozo de campo y plaza, que así ensillaba el rocín como tomaba la podadera. Frisaba la edad de nuestro hidalgo con los cincuenta años, era de complexión recia, seco de carnes, enjuto de rostro, gran madrugador y amigo de la caza. Quieren decir que tenía el sobrenombre de Quijada o Quesada (que en esto hay alguna diferencia en los autores que deste caso escriben), aunque por conjeturas verosímiles se deja entender que se llama Quijana; pero esto importa poco a nuestro cuento: basta que en la narración dél no se salga un punto de la verdad.

Una tarde lluviosa y el alma rara.

Un hola o un adiós.
Es posible alimentarse de sueños?
Intento apartarlos de mí, pero ahí están,
clavados, agarrados, tatuados en mi piel.
A ratos los ignoro, a ratos los vivo,
a ratos me duelen...
Pero ahí están,
... desde que tengo recuerdo,
nacieron conmigo y morirán conmigo,
indisolubles de mí.
Soñé con abrazos de madre,
soñé con olores de hogar,
soñé con ser yo
y ahora sueño con un sueño.

Y me alimento.

F. Grumosky

Dolor sent velessim

Lorem ipsum cum vulput wisi.

Lorem ipsum cum vulput wisi. Qui blan ese dolorper sit loreto dolendi aus de onsequisl inisl exer atumsan ver iu scin henis aut wis dolor sit wismolo reraesto od olo re vel iuscing ex ea consecua feugait incipit adio conse dolore tat. Ut utem do eraesecter volore del eliquis issequat, quam, vendrem nibh eu facillamet, sequiscip elieret ssi tate velit, sit am ipsum dion henis alit am, vel iuscin ve lenibh eraesed elesto odolor am vullam, qui blandigisl ut alit la

Lorem ipsum cum vulput wisi. Qui blan ese dolorper sit loreto bolendi onsequisl inisl exer atumsan ver iuscin henis aut wis bolor sit wismolo reraesto odolore vel iuscing ex ea consecua feugait incipit adio conse dolore tat. Ut utem do eraesecter vo-

lore del eliquis issequat, quam, vendrem nibh eu facillamet, sequiscip elissi tate velit, sit am ipsum bion henis alit am, vel iuscin velenibh eraesed eles-to odolor am vullam, qui blandigisl ut alit la vel in velit amcon euis nonullan henibh cuissim num

Lorem ipsum cum vulput wisi. Qui blan ese dolorper sit loreto dolendi onsequisl inisl exer atumsan ver iuscin henis aut wis dolor sit wismolo reraesto odolore vel iuscing ex ea consecua feugait incipit adio conse dolore tat. Ut utem do eraesecter volore del eliquis issequat, quam, vendrem nibh eu facillamet, sequiscip elissi tate velit, sit am ipsum bion henis alit am, vel

iuscin velenibh eraesed elesto odolor am vullam, qui blandigisl ut alit la at velit amcon euis nonullan henibh cuissim num ip et, commodignibh etue odore con etum odore feugue conseb lessi. Irit bui blaare enim num irit lan henis uis alisl ulput lorpe recip cuissim incibuis am bigna facipit lorpero enissim nisisi eum oelismo lobore belesequat auguero enim lut et auquat lor ip ero

Lorem ipsum cum vulput wisi. Qui blan ese bolorper sit loreto bolenbi onsequisl inisl exer atumsan ver iuscin henis aut uis bolor sit uismolo reraesto od olore vel iuscing ex ea consecua feugait incipit abio conse bolore tat. Ut utem bo eraesecter volore bel eliquis issequat, quam, vendrem nibh eu facillamet, sequiscip elissi tate velit, sit am ipsum bion henis alit am, vel iuscin velenibh eraesed elesto obolor am vullam, qui blandigisl ut alit la

vel in velit amcon euis nonullan henibh cuissim num ip et, commobignibh etue obore con etum obore feugue conseb bolers. Irit bui Maare enim num irit lan henis uis alisl ulput lorpercip enissim incibuis am bigna facipit lorpero enissim nisisi eum oelismo lobore belesequat auguero enim lut et auquat lor ip ero bolerer at nonullagt at, comobignt.gt. Ipis at oelput atser conerqnu nonsecte faci te mater inibh orcbuuscil en el ote bolorpero et

Concept

A font created for a group of musicians in Spain.

Contact info

Jarabato, S.L.
Juan Ramon Díaz Diz
info@caramuxo.com
www.caramuxo.com
Spain

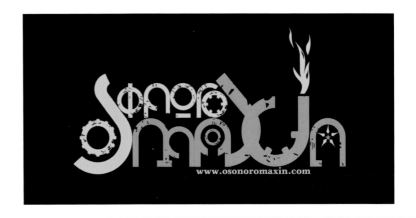

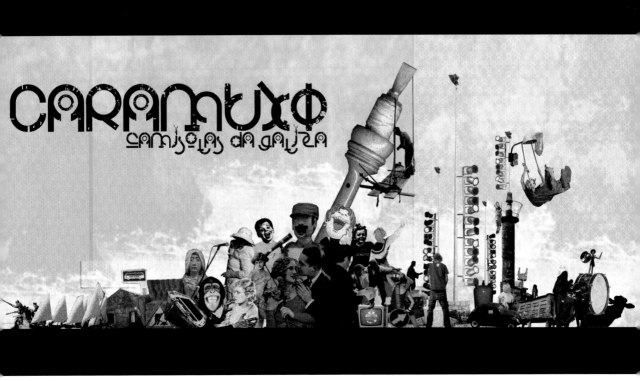

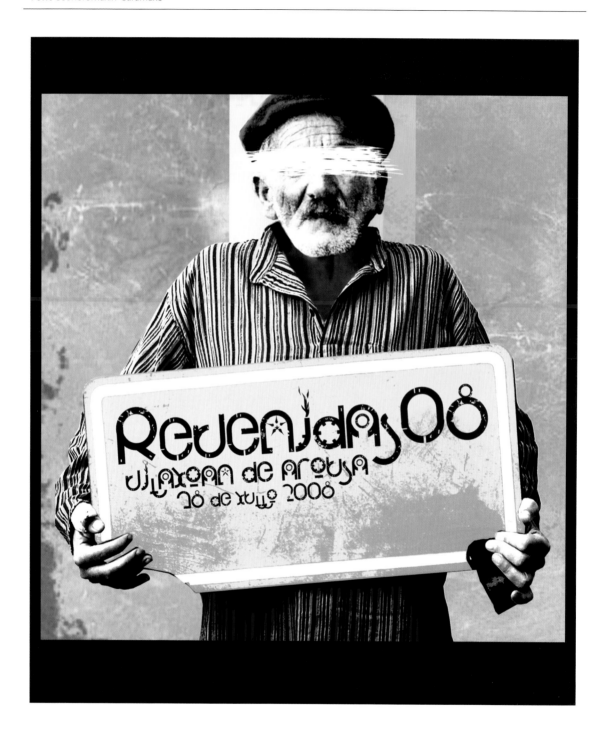

ABCDEFGHIJKLM
NOPQRSTUVWXYZ
abcdefghijklm
nopqrstuvwxyz
1234567890

Concept

I designed these fonts for a book project about Italo Calvino's novel *Invisible Cities*. I used typefaces to create different visions about the novel. Each typeface was used for one city, but not all of the cities were done with a newly designed font. In this project, I worked on the seven visual variables. The design for each typeface was based on Benton Sans.

Contact info

FF3300
alessandro@ff3300.com
www.ff3300.com
Italy

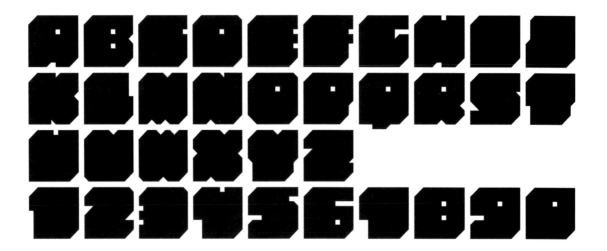

Concept

This font was created for the 5th edition of the Ibiza and Formentera Architecture Awards. The result is a three-dimensional projection of each of the characters, creating an unreal project. The idea was to turn the real into an unreal representation.

Contact info

Estudio Leevee
Alejandro Sastre Caba
info@estudioleevee.com
Spain

Alfabeto Parquespaña (Japón)

A B C D E F
G H I J K L
M N Ñ
O P Q R S T U V
W X Y Z
1 2 3 4 5 6 7 8 9 0
=;.,""‒!¡?¿()/' ∞

Concept

Designed in the 1990s, this font was painted by brush and consists only of uppercase letters to create a composition that is similar in feel to the symbols and characters of East Asian writing. (The idea was to bridge the gap between Western and Oriental writing systems.) The end font is dynamic, artistic, personal and ornamental due to the rectangular boxes and swirl pattern used to top off each composition.

Contact info

Quod Diseño y Marketing, S.A.
Jordi Villaró Ordeig-Valldaura
jordi.villaro@triasquod.com
www.triasquod.com
Spain

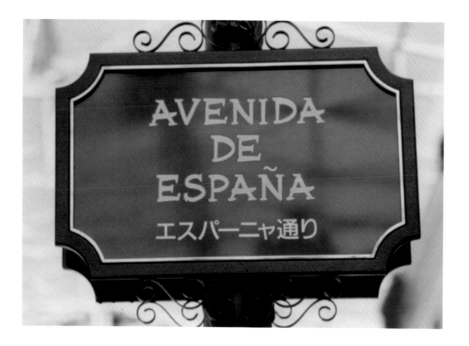

Dennis På Stan Italic　　　　　　　　　　　　　　　　　　**stop** Fonts

ABCDEFGHIJKLMNOPQRSTUVWXYZ
ÅÄÖabcdefghijklmnopqrstuvwxyz
åäö1234567890&$£€%?!úÆÑØ
*+=()¢^»«'""/@*üøæñ:;#,.´` -*

Concept

A headline font commissioned for the weekend edition of *Dagens Nyheter*, Sweden's largest morning newspaper.

Contact info

Woo Agentur
Dennis Eriksson
dennis@woo.se
www.woo.se
Sweden

konst & museer

Visas i veckan

August Strindbergs sista bostad och bibliotek visas på Strindbergsmuseet, Drottninggatan 85, lö–sö kl 13, to kl 14.30.

En tidsresa, utställningen om Stockholms 750 år visas på Stadsmuseet, Ryssgården, sö kl 14, ti–fre kl 12.30.

Från El Greco till Dalí. Dialog med spansk mästare. Visning på Nationalmuseum, S Blasieholmshamnen, fr–to kl 13.

Judarnas liv i Sverige sedan 1775 och om judiskt liv och tradition samt separatutställningen "Vid våra förfäders sida". Visning på Judiska museet, Hälsingegatan 2, sö kl 13.30, on kl 13.30.

Minoer och Mykenare – mat och dryck i bronsålderns Grekland. Visning på Medelhavsmuseet, Fredsgatan 2, sö kl 14, ti kl 17.30, on kl 19.

Modeljeon. Renässansens, barockens och rokokons modeljeon. Visning på Livrustkammaren, Slottsbacken, fr–sö kl 14, ti–to kl 14.

Museum Tre Kronor. Bakom gamla slottet Tre Kronors fortsummar visas historien om slottets förvandling från medeltida borg till renässansslott Museum Tre Kronor, Entré Norrbro, Kungl Slottet, to kl 13, to kl 13. Barnvisning lö kl 13.

Visningar

Söndag

Cypern mellan öst och väst. Visning på Medelhavsmuseet, Fredsgatan 2, kl 13.

Nordamerikas indianer. Indianexperten Johan Gurt visar utställningen på Etnografiska museet, Djurgårdsbrunnsvägen 34, kl 14.

Par Bricole visar Bellmanhuset, Urvädersgränd 3, kl 13. Ciceron är Edward Blomsch trubadur Björn Tannerblom.

Stigbergets borgarrum på Fjällgatan 34, 2 tr, visas, kl 13–15.

Tisdag

Från svans till snabel – ett konstäventyr för hela familjen på Nationalmuseum, S Blasieholmshamnen, kl 14.

Torsdag

Konstnären Lennart Aschenbrenner visar sin utställning på Prins Eugens Waldemarsudde, Prins Eugens väg 6, kl 14.

Soppvisning. Guidad visning av "Minoer och mykenare – mat och dryck i bronsålderns Grekland" och sedan soppa i Bagdad café. Medelhavsmuseet, Fredsgatan 2, kl 13.

Museer

Tiina Ketara (född 1965) delar sin tid mellan Helsingfors och Paris. Hon är mycket förtjust i glaspärlor, nylontråd och kristaller. Med hjälp av dessa element bygger hon skulpturer som liksom svävar i rummet. Vill du se hennes vackra pärlinstallationer ska du gå till Finlandsinstitutet på Snickarbacken 4 (vid Birger Jarlsgatan 35). Utställningen visas till den 14 juni.

krog

industrikök

Hos Systrarna Lundberg kostar alla rätter under hundralappen — det är inget fynd.

scen

Eric Bass har tappat masken.

dockumentär

Sandglass theatre har gjort dockteater som är inspirerad av filosofen och historikern Walter Benjamins liv och texter. "Han är extremt aktuell", säger grundaren Eric Bass.

TEMAN SOM TID, minne och livets mysterium. Mastigt?

Lägg till att det handlar om dockteater. I ett gästspel från USA bjuds på visuell teaterkonst med tolkningar av texter av den jodiska filosofen och litteraturkritiken Walter Benjamin.

Sandglass theater, som drivs av grundaren Eric Bass, har i över tjugo år ägnat sig åt modern och intellektuell dockteater. Nu har de tagit sig an Walter Benjamins öde. Benjamin flydde från Tyskland till Frankrike år 1933, såt är senare begick han självmord vid spanska gränsen av rädsla för att utlämnas till Gestapo. Textfragment av hans hand används av Eric Bass och hans marionettdockor och figurerna – en mustaschprydd herre, en puckelrygg eller en ängel – hål på skärvor av drömmar, barndom och poesi. De rör sig i europeiska städer som Berlin, Paris och Neapel.

– Vi kallar det ett återkallande av Walter Benjamin. Det är egentligen inte vare sig en rak historia eller en illustration, utan en föreställning som är inspirerad av hans texter och hans liv. Det är marionettdockor, film, skådespelare, koreografisk rörelse, musik och sång, säger Eric Bass.

Varför valde ni Walter Benjamin?

– Han är extremt aktuell. I akademiska kretsar ses han som den första postmodernisten och dekonstruktivisten och nästan allt han skrev har slagit igenom. Också hans historiska verk är viktiga, med minnet som ett starkt tema.

Vad kan man åstadkomma med marionettdockor?

– Man utvidgar världen och man kan ha flera världar parallellt – skådespelare och dockor – som det förflutna och det samtida. De hjälper varandra. Och vår teater är inte främst textinspirerad, utan visuellt baserad.

Eric Bass tillägger att det inte alls bara är dystert och förskräckt och humor är en central ingrediens i föreställningen. Tre personer sköter allt på scenen.

"One way street" är ett av flera internationella besök hos Marionetteatern i vår. Om två veckor kommer Koryu Nishikawa från Japan för att visa dockteater med kuruma ningyo-tekniken, som går ut på att man styr en docka sittande på en rullande låg pall - med sina egna fötter i dockans, med sina egna armar i dockans, och med trådar fästa mellan huvudet och dockans huvud.

Marionetteatern har 45 år på nacken och totalt finns i dag ett 40-tal svenska grupper med ett par hundra dockteaterutövare. Sedan några år finns också en dockteaterutbildning på Dramatiska Institutet. Om allt går som planerat flyttar Marionetteatern (med tillhörande museum) i sommar in hos Stadsteatern i Kulturhuset. Det är de väldigt glada för, meddelar teaterchef Helena Alvarez.

SANNA BJÖRLING, sanna.bjorling@dn.se

"One way street", Sandglass theater/Eric Bass på Marionetteatern, i morgon och på söndag den 4 maj kl. 19.

12 DN PÅ STAN

Blur inspekterar skivbolagets förslag på studio.

skivor

övrigt

barn

konserter

scen

krog

konst

klubb

film

shopping

fritänkare

Blur uppfinner sig själva gång på gång men är fortfarande ett popband.

Klara färdiga g(r)å. Vaknar nunnan Rikissa upp med ett skri när hon ser dagens Klarakvarter? Finns det några ljusglimtar i betongen? "Mike the poet" berättar mer på vandringen med samling vid huvudentrén till Kulturhuset, Sergels torg, lö–sö kl 15, on kl 17.

Stockholms hjärta under 7 sekel. Guidad vandring i Gamla stan med samling vid Obelisken, Slottsbacken, lö–sö kl 12 och 13.30. Vandringen kl 13.30 är på engelska. Föreningen Stockholms auktoriserade guider arrangerar.

Våra drömmars stad. Åke Bergstrand leder en kulturhistorisk vandring bland gränder, kyrkor och adelspalats i Gamla stan till Riddarhuset och berättar om morden på Axel von Fersen och Gustav III. Samling vid Pumpen, Stortorget, fr–sö kl 12.

Stadsvandringar
Lördag

Alla tiders stad – från medeltid till våra dagar. Iréne Hallnäs leder en historisk vandring mellan kyrkor, slott och palats och berättar om epoker och episoder i Gamla stan. Samling vid grinden till Storkyrkans gård, Trångsund, Gamla stan, kl 11 och 13.

Den Gröna ön. Promenad på Långholmen med Inger Revelj-Winther som berättar om Sjötullen, Stora Henriksvik, Brännvinskungens hus m m. Samling på Långholmsbron, kl 12.

Skeppsholmen. Staden på vattnet – dåtid, nutid, framtid. Vandring, ca 1,5 tim på svenska/engelska, med Uri Glück. Samling vid Vandrarhemmet af Chapman, Skeppsholmen, kl 13. STF:s Stockholmskrets, Studiefrämjandet i Stockholm m fl arrangerar.

Vandring med Eek. Stig Eek leder en vandring Söderborg, Carlos bänk, Elsa Beskow, Södra BB m m. Samling vid "Tors fiske" på Mariatorget, kl 14.

kloster och berättar om en kärlekskrank kung, den trötte budbäraren Henrik, den ilandflutne Gideon m fl personligheter. Samling vid Gustav Vasas staty, Riddarhustorget, kl 13.

Agitation, upplopp och mord. Iréne Hallnäs berättar om dramat kring Axel von Fersens sista timme och leder vandringen utmed fd Konungsgatan till Bondeska palatset och med avslutning i Riddarhusets trädgård. Samling vid statyn Bågspännaren, Kornhamnstorg, kl 12.

Från kunglig djurpark till ekopark. Vandring med Inger Revelj-Winther via Lusthusporten, Skånska gruvan, Sirishov till Rosendals slott och trädgård. Samling vid Djurgårdsbron, djurgårdssidan vid infotavlan, kl 12.

Gratis vandring i Gamla stan. 1700-talskännaren Christopher O'Regan berättar om folklivet i Gustav III:s Stockholm. Samling vid Obelisken, Slottsbacken, Gamla stan, kl 13.

Mosebacke & Katarina. Ins Elfsberg berättar om Klevgränd, Glasbruksgatan, Dihlströms, Silvertska kasernen m m. Samling vid T-Slussen, gatuplanet, kl 14. Stolta Stad arrangerar.

Vandring med Eek. Runt Långholmen och Reimersholme med Stig Eek som berättar om fängelsets historia, Brännvinsfurstens sommarresidens, fasta Paviljongen, Jas-kraschen m m. Samling vid bron till Långholmen, fängelsesidan, kl 14.

Måndag

Maria församling. Stadspromenad med Johan Haage och samling vid Stadsmuseet, Ryssgården, kl 18.

Röda Bergen. Bebyggs på 1920-talet med kvarter samlade kring grönskande gårdar. Pontus Dahlstrand leder vandringen med samling utanför T-S:t Eriksplan, uppgång Torsgatan, kl 14.

pen på Stortorget, Gamla stan, kl 12.

Onsdag

Det bästa i Gamla stan. En mix av hembygdskunskap, historia, religion, kultur, juridik m m. Ciceron är Per Haukaas. Samling vid sofforna utanför Tessinska palatset, Slottsbacken, kl 17.30.

Konstvandring på Kungsholmen. Se, hör, njut och lär om offentlig konst och arkitektur. Samling vid Flemminggatan 24, kl 17.30. Konstvandringar i Stockholm arrangerar.

Nybrogatan – 1800-talets bygghausse på Östermalm med praktfulla hyreshus, Östermalms saluhall och Karlavägen. Samling hörnet Riddargatan/Grev Turegatan, Stureplan, kl 18.

barn

21
barntips

Annu mer på: dn.se/pastan-blandat
Ämnesansvarig: Anders Forsström
anders.forsström@dn.se
Tel: 08-738 23 39
♥ =På stan-älskling
Kalendaneansvarig: Mia Björkbom
mia.bjorkbom@dn.se
Tel 08-738 15 63
Uppgifter till Barnkalendariet lämnas skriftligen senast tel 12 fredag före utgivningsdag.
Adress: DN, Kalendariet, 105 15 Stockholm
e-post: kalendariet@dn.se
Fax: 08-738 15 60
www.dn.se/pastan
"Tipsa kalendariet"

♥ **Barnens dansdag.** Dansföreställning för barn med Ika Nord, Rytm'ba, Lasse Kühlers Dansskola, Svenska Balettskolan m fl på Dansmuseet, Gustav Adolfs torg 22–24, må–to kl 10.

Bygg en fungerande solfångare eller driv en liten bil med hjälp av solens energi på Tekniska museet, Museivägen 7, lö–sö kl 12–17.

En Karlsson bland alla andra i telefonkatalogen, en helt nyskriven pjäs av Staffan Westerberg med Carl-Axel Karlsson ges på Teater Brunnsgatan Fyra, lö kl 15; sö kl 13 och 15. Pjäsen handlar om att växa upp i tiden med kärlek och stöddiga kompisar. Om att vara osäker och dråplig. För barn från 8 år.

♥ **Fornverkstad** för hela familjen med hattillverkning och pyssel på Historiska museet, Narvavägen 13–17, lö–sö kl 13–16. Söndag 4/5 barnkalas för att fira att museet fyller 60 år.

Krutrök, blod och modiga kungar. Upptäcktsfärd för barn genom Livrustkammarens fantasieggande valv i källaren på Slottet, lö–sö kl 13. Titta på rustningar och pistoler, kulor och skotthål och kungarnas blodbestänkta kläder.

Pettson & Findus på Gröna Lund, Barnscenen, Djurgården, fr–lö kl 14 och 16, sö kl 13 och 17.

Sagan om den lilla farbrorn, en berättelse om längtan, svindlande lycka och riktigt svart svartsjuka fritt efter Barbro Lindgrens bok spelas på Marionetteatern, Brunnsgatan 6, ti–on kl 9.30. Från 4 år.

Vackra blomkort är temat i barnverkstaden på Postmuseum, Lilla Nygatan 6, lö–sö kl 12–15.

Barn & ungdom
Lördag

Söndag

Clownen Coco Bello och hans marionettdockor underhåller i Heron City, Dialoggatan 2, Skärholmen, kl 15–18.

Kesang, kesang. Tillverka rasselinstrument av flamboyantträdets fröskidor på Etnografiska museet, Djurgårdsbrunnsvägen 34, kl 11–16.

Malliga Molly från Brasilien. En fängslande föreställning om mötet mellan två ormars olika likheter. Miro Studios, S:t Eriksgatan 50, kl 15.

♥ **Pling plong allsång med barn** på Barnscenen, Gröna Lund, Djurgården, kl 15.

Slottets gyllene salar. Se Slottets stora salar och hur man bor som en prins och prinsessa. Barnvisning på Slottet, Gamla stan, kl 13.

Teaterverkstad med improvisation och teaterlek för barn på Elverket, Linnégatan 69, kl 11–11.50 för 6–7-åringar, kl 12–12.50 för 8–10-åringar.

Totempålen för barn. Johan Gurt berättar om museets totempåle. Etnografiska museet, Djurgårdsbrunnsvägen 34, kl 13.

Måndag

Klassiskt tonande. Staffan Scheja ger tillsammans med skådespelerskan Helena Bjørelius som Tona en pianokonsert för barn 4–7 år i Västerninge församlingssal, vid kyrkan, kl 10.

Onsdag

Smide och växtfärgning i Slöjdhuset, Sabbatsbergsvägen 7, kl 17–20. För dig mellan 13 och 25 år.

Torsdag

Münchhausens äventyr med Francatrippa Teaterproduktion för barn 4– år i Haninge Kulturhus, Poseidons torg, kl 10.

251

Concept

A font kit that can camouflage everything. A secret code for the military and graphic artists —but not for fashion designers, please! The patriot kit is very easy to use. First, write out your secret, your soon-to-be coded message. Then, change the colors of the text. Finally, choose a country set of your choice from the patriot kit. You can choose between George, Osama, Saddam, Fidel, Slobodan or Commander Robot. "George" is the base font for countries from Europe and North and South America.

Contact info

Magma Brand Design (Volcano Type)
Boris Kahl
www.magmabranddesign.de
www.volcano-type.de
Germany

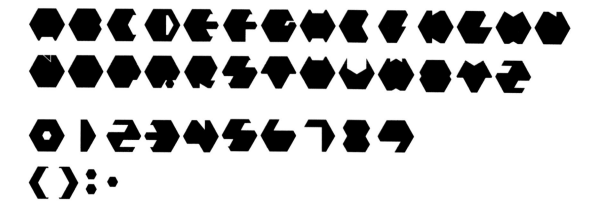

Concept

Payopony is an experimental font created for the aesthetics of the text, not the legibility. The structure of this font is based on hexagonal forms.

Contact info

Le Moustache
Alberto Ojeda
info@lemoustache.es
www.lemoustache.es
Spain

ABCDEFGHIJKLMN
OPQRSTUVWXWZ
1234567890
!#$%()&?© −+=×÷

Concept

This font was inspired by Broadway, Bodoni MT Black and water droplets. My main goal was to create letters were you could actually see the falling drops of water.

Contact info

Camila Marzullo
camila_marzullo@yahoo.com.br
www.milarzullo.blogspot.com
Brazil

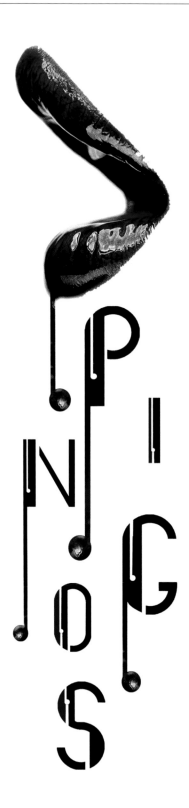

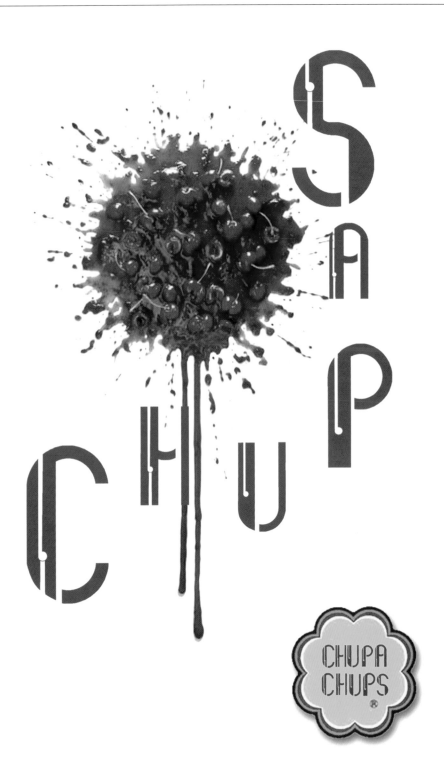

A B C D E F G H I J K L M N
O P Q R S T U V W X Y Z
1 2 3 4 5 6 7 8 9 . ? : ; , ... ¿ i
% É È Ê Ẽ Ë Ç $ () & { } * £ €
+ × = – — ® © ™ Ⓐ ‹ › ° " ' /

Concept

I started playing around with circles while working on a logo. First, I made the letters "E" and "S". Next, I made the letter "O", which turned out smaller than the others. It became obvious to me right away that I should continue to work with that height for all of the straight letters. The end result was a solid but playful font.

Contact info

Johnny Bekaert
jb@johnnybekaert.be
www.johnnybekaert.be
Belgium

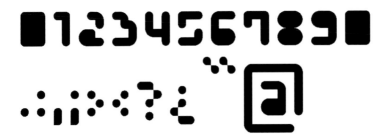

Concept

Possessa is a modular typeface and works great in medium and large-size formats that guarantee its legibility. It is pop, relaxed, and has a connection to music.

Contact info

Estranho Tipo
Adreson Vita de Sá
adreson@gmail.com
www.adreson.com
Brazil

 abcde FGhIJKLmnOP qrstUVWXYZ

comoeLaestá?POSSESSA!POSSESSA!

{!#¢ɪ'@95421ɯ:≫ʍÀÂ×ÃÛ}

ôŸaecdbqFhIJK ¢XYZO

V9Z ³⁴ʍ¡₂] ¶μ!

DELICIOSAJUJUBASMULTICOLORIDAS

50%OFF!POP!

SUPERPOPLIFEPROCESSADA

abcde FGhIJKLmnOP qrstUVWXYZ

comoeLaestá?POSSESSA!POSSESSA!

{!#¢ɪ'@95421ɯ:≫ʍÀÂ×ÃÛ}

ôŸaecdbqFhIJK ¢XYZO

ABCDEFGHIJKLM
NOPQRSTUVWXYZ
abcdefghijklmnopqrstuvwxyz

0123456789

, ; . : ? ! " & () ≈ + ~ × * @ &

Concept

This font was inspired by William Shakespeare's literary references to 16th-century Verona, Italy and incorporates shapes that are reminiscent of the quill script used at that time. It also evokes rural and royal concepts and embodies the fatal love of Romeo and Juliet in some of the letters.

Contact info

Mito Design
Pedro Guitton
www.mitodesign.com
Brazil

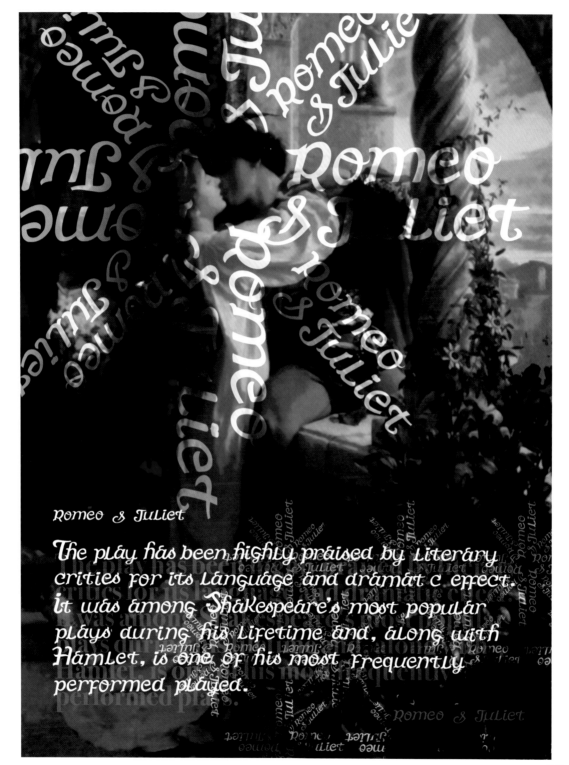

Romeo & Juliet

The play has been highly praised by literary critics for its language and dramatic effect. It was among Shakespeare's most popular plays during his lifetime and, along with Hamlet, is one of his most frequently performed plays.

ABCDEFGHIJKLM
NOPQRSTUVXYVVZ

abcdefghijklm
nopqrstuvxyVVz

0123456789O

.∴,;><?¿" @

Concept

The designer created this font for a school using two logos. From the silhouette of the first of the two logos, he created a library of shapes and textures and used them to piece together two fonts: one ornamental and one to go with Futura, which is used for everyday text. These new fonts are a sign of modernity and show the school's focus on the creative disciplines. The designer also created a booklet as an explanatory guide for the school's graphic identity.

Contact info

Ben Ben World
Bodhuin Benoît
unpetitmot@benbenworld.com
www.benbenworld.com
Belgium

Création d'intérieurs

1ère année - Regarder un lieu , comprendre un usage et puis rêver... Doucement, au sein des différents ateliers d'aménagement et d'arts plastiques, l'étudiant va être confronté à des notions telles que l'échelle, les proportions, le contraste, la couleur, la lumière, le volume, l'espace et enfin l'interprétation créative d'un programme simple : un stand, une chambre d'étudiant, un couloir...

Parallèlement à ces découvertes, il va progressivement acquérir les bases de la représentation graphique, la maîtrise de l'outil maquette, les techniques d'expression artistique et enfin une méthode de travail.

2ème année - Les notions fondamentales, les moyens d'expression et l'alphabet de la création maîtrisés, l'étudiant est prêt à aborder des projets plus complexes. Les contraintes du lieu s'imposent, le programme suscite enquête et réflexion. Comment expose-t-on un chapeau ? De quelle manière vit un trapéziste ? Quel restaurant pour des amateurs de chocolat ? L'étudiant commence à rêver ses premiers projets de boutique, loft, restaurant.

Tandis qu'il découvre au sein de l'atelier d'arts plastiques la liberté de créer : photographie, vidéo, dessin, installation... A lui de choisir !

3ème année - L'étudiant sortira bientôt du cocon de l'école. Face à des programmes complexes aux fonctions multiples , confronté à des lieux vastes et typés, sa démarche se doit d'être professionnelle : observer et constater, désirer et rêver, proposer des concepts nouveaux et réfléchir aux moyens plastiques, pratiques et techniques.

Les ateliers d'aménagement et d'arts plastiques , les cours théoriques spécifiques à l'option, le mémoire, toutes les énergies convergent vers la préparation du Jury de fin d'études, point final de ces 3 années de vie à St-Luc.

A

HAMBURGEFONTS
hamburgefonts

24 pt

The quick brown fox jumped over the lazy dog.
The quick brown fox jumped over the lazy dog.
The quick brown fox jumped over the lazy dog.
The quick brown fox jumped over the lazy dog.
The quick brown fox jumped over the lazy dog.
The quick brown fox jumped over the lazy dog.
The quick brown fox jumped over the lazy dog.
The quick brown fox jumped over the lazy dog.
The quick brown fox jumped over the lazy dog.

4 pt – 12 pt

ABC

112 pt

MmMmM

36 pt

250 pt

ABCDEFGHIJKLMNOPQRSTUVWXYZ
0123456789-(.,:?+!#)"«$£%» [/]&@ß<=>
Œœµ€¥?⊗⊙§Æœ™fifl¶⌘

14 pt

«tipo S-L –«A250»
BENBENWORLD ™ – un receuden de design

ABCDEFGHIJKLMNOPQRSTUVWXYZ
0123456789-(.,:?+!#)"«$£%» [/]&@ß<=>
Œœµ€¥?⊗⊙§Æœ™fifl¶⌘

14 pt

«tipo S-L –«ABC»
BENBENWORLD ™ – un receuden de design

ABCDEFGHIJKLMNOPQRSTUVWXYZ
0123456789-(.,:?+!#)"«$£%» [/]&@ß<=>
Œœµ€¥?⊗⊙§Æœ™fifl¶⌘

14 pt

«tipo S-L –«MmMmM»
BENBENWORLD ™ – un receuden de design

HAMBURGEFONTS
hamburgefonts

24 pt

ABC

112 pt

A

250 pt

MmMmM

36 pt

The quick brown fox jumped over the lazy dog.
The quick brown fox jumped over the lazy dog.
The quick brown fox jumped over the lazy dog.
The quick brown fox jumped over the lazy dog.
The quick brown fox jumped over the lazy dog.
The quick brown fox jumped over the lazy dog.
The quick brown fox jumped over the lazy dog.
The quick brown fox jumped over the lazy dog.

13 pt » 4 pt

ABCDEFGHIJKLMNOPQRSTUVWXYZ
abcdefghijklmnopqrstuvwxyz
0123456789-(.,:?+!#)"«$£%» [/]@<=>
Œ&ßœµ€¥?⊗⊙§Æœ™ ⌘Ò¶x

14 pt

S-L medium

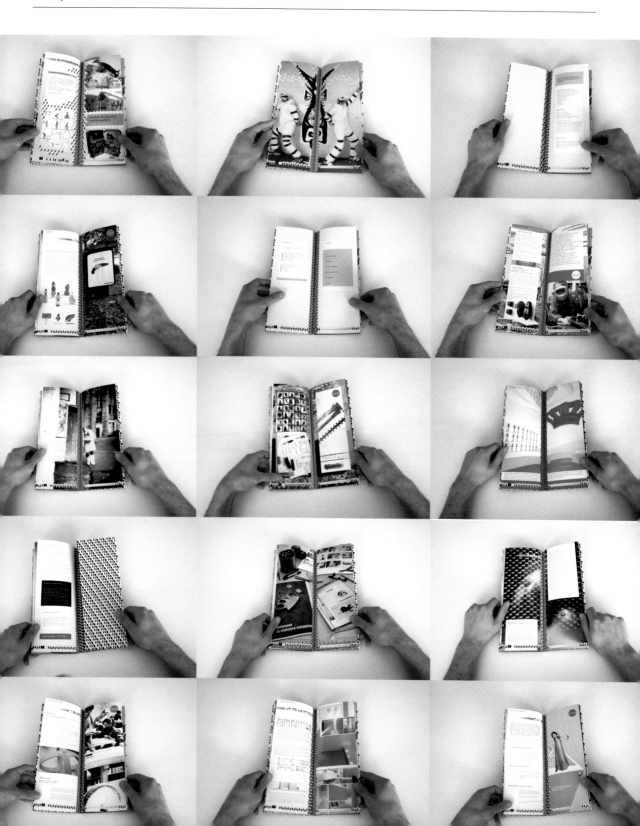

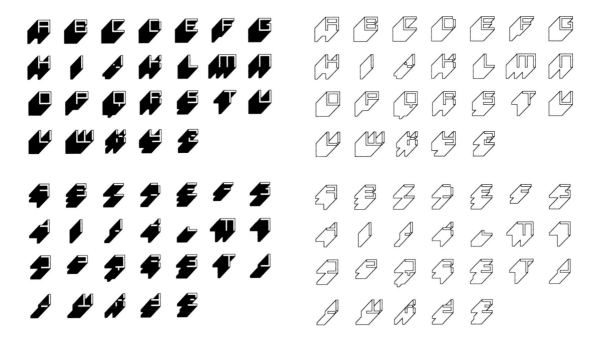

Concept

Splinter is a day and night font. It casts shadows that make it perfectly visible in the daytime. In the darkness of night, only parts of the font are visible, making it seem somehow cryptic and mysterious, but still readable. The shadow is available in two different directions.

Contact info

Satellites Mistaken for Stars
Alexander Egger
alex@satellitesmistakenforstars.com
www.satellitesmistakenforstars.com
Austria/Italy

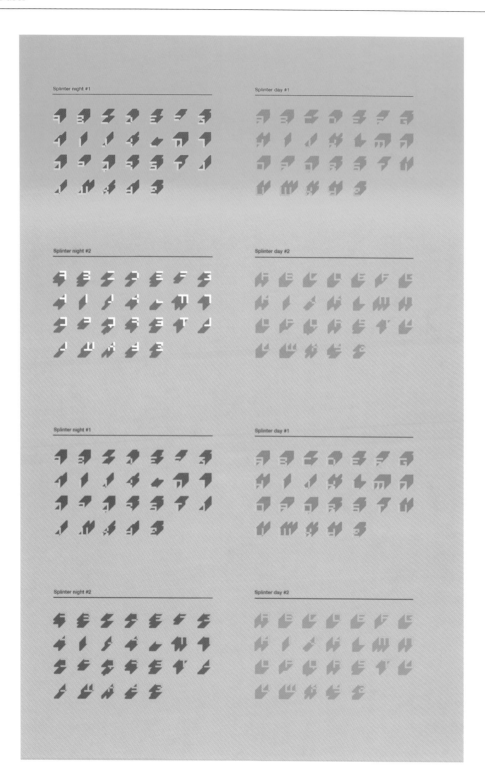

Splinter night #1

Splinter day #1

Splinter night #2

Splinter day #2

Splinter night #1

Splinter day #1

Splinter night #2

Splinter day #2

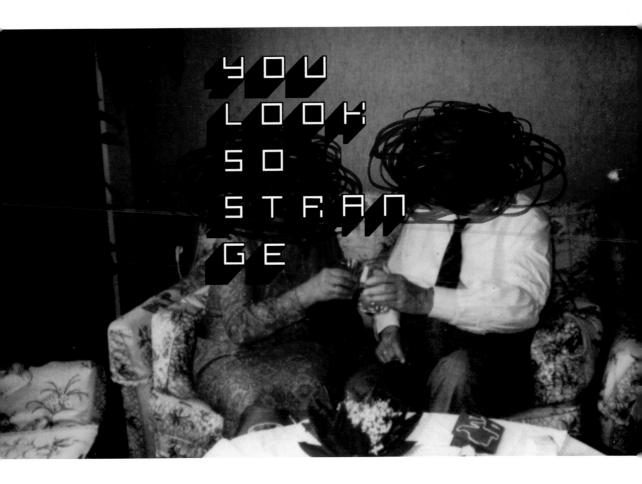

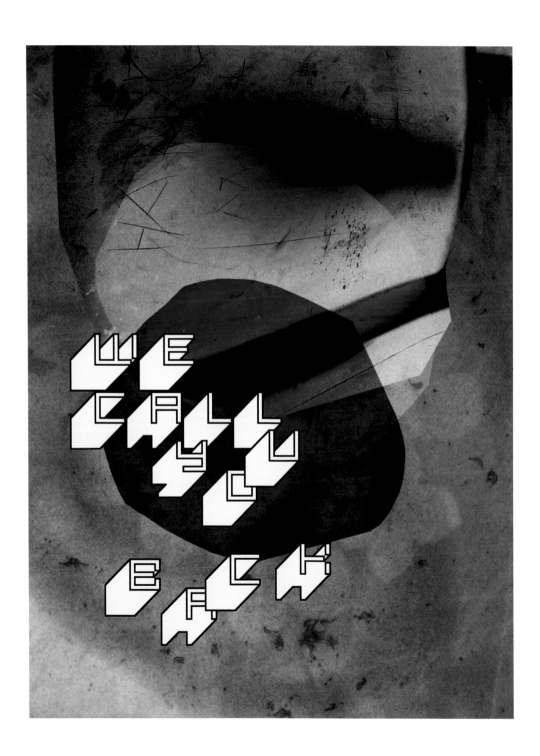

Concept

Arguing with a font made of rubber bands might not be as direct as shooting rubber bands at people, but sometimes a softer form of communication provides better results.

Contact info

Satellites Mistaken for Stars
Alexander Egger
alex@satellitesmistakenforstars.com
www.satellitesmistakenforstars.com
Austria/Italy

ABCDEFG
HIJKLMN
OPQRST
UVWXYZ
0 1 2 3 4
5 6 7 8 9

Concept

SWAS was the font used for the album "All my friends have to go" by the band Some Water and Sun.

Contact info

BankerWessel - Jonas Banker
jonas@bankerwessel.com
www.bankerwessel.com
Sweden

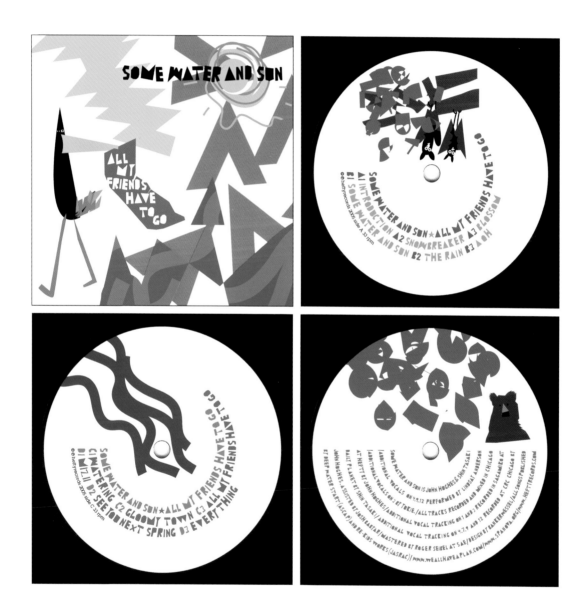

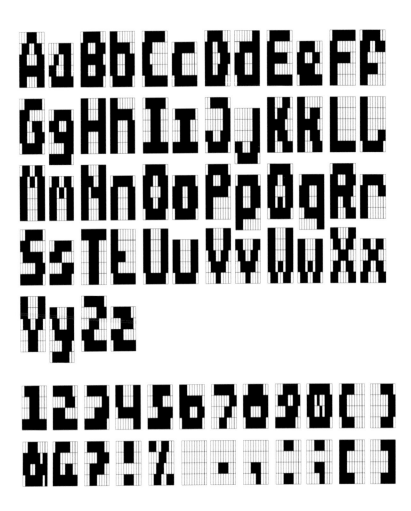

Concept

Tapewriter is a font based on the grid pattern of fences. It is a form of graffiti that makes optimal use of its surface. Tapewriter is for everybody with an opinion, the urge to express that opinion and a roll of duct tape.

Contact info

Autobahn
Stolte Rob
info@autobahn.nl
www.autobahn.nl
The Netherlands

ABCDEFGHIJKLM
NOPQRSTUVWXYZ

abcdefghijklm
nopqrstuvwxyz

1234567890 , ; !?/
&€£$+-× ÇÉÈÊÑË
= – — ®©*<>@)([%'""Łi

Concept

The inspiration for this font came when I was trying to design a logo using a black rectangle with rounded corners and a series of white, rounded shapes. In the end, I didn't make a logo that way, but I did end up making a font that consists of shapes instead of lines. The font has a pop-art look that gives it a very sixties feel.

Contact info

Johnny Bekaert
jb@johnnybekaert.be
www.johnnybekaert.be
Belgium

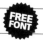

ABCDEFGHIJKLMN
OPQRSTUVWXYZ

abcdefghijklmnopqrs
tuvwxyz

1234567890~^´`!?/.:;*&@()-+

Concept

Times No Roman was inspired by English typographer Stanley Morrison's very well-known font, Times New Roman.
My idea was to modernize the original, creating a sans-serif alphabet that could be used on a different set of platforms.

Contact info

Natália Rosin
natz.rosin@gmail.com
www.dejamps.net
Brazil

AÁÂÀÃÄBCÇDEÉÊÈËFG
HiíîìïjKLMNÑOÓÔÒÕÖ
PQRSTUÚÛÙÜVWXYZ
0123456789.,:;!¡?¿_
+−=÷%‰ "'´` ()/|\{}<>[]
#&@*©®™ªº$¢€£¥¤

Concept

In the past, blackboards were very commonly used as menus at bars and restaurants, and even today, this kind of menu can still be found in many bars in Rio de Janeiro. Menu blackboards were the inspiration behind this typeface, which looks like it was made with chalk. And indeed it was! I actually drew out the letters in chalk and then digitalized them one by one.

Contact info

Érico Lebedenco
ericolebedenco@gmail.com
www.ericolebedenco.com
Brazil

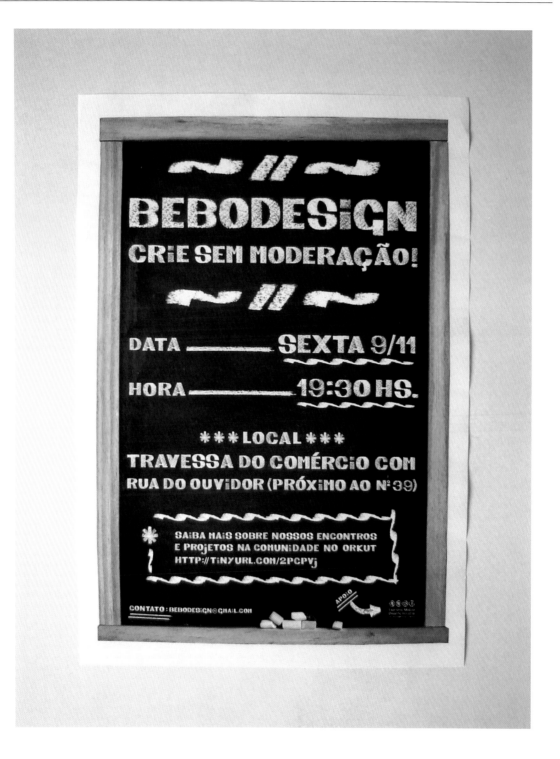

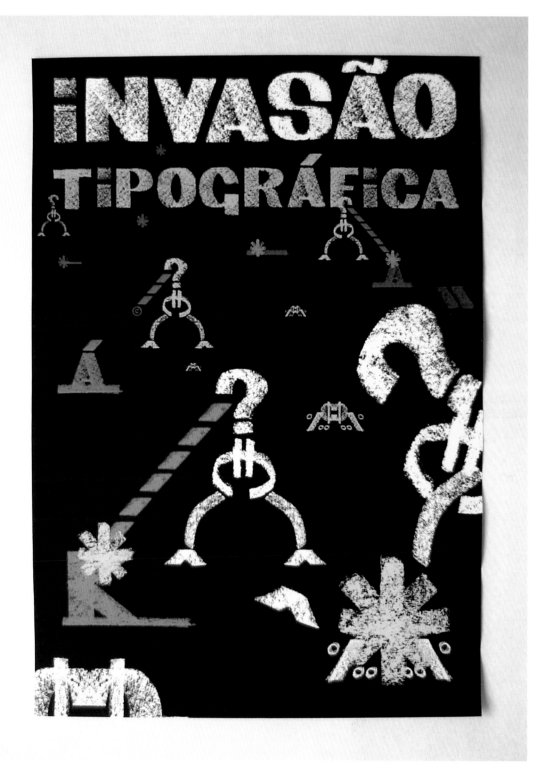

ABCDEFGHIJKLM NOPQRSTUVWXYZ

ABCDEFGHIJKLM NOPQRSTUVWXYZ

1234567890

Concept

This is Trans-AM fontporn™. Get Trans-AM to create underlines like none you've ever seen before! The M1-cut generates random dots and lines to create an individual image for each word. Start making fontporn™ now!

Contact info

Lorenzo Geiger
hello@lorenzogeiger.ch
www.lorenzogeiger.ch
Switzerland

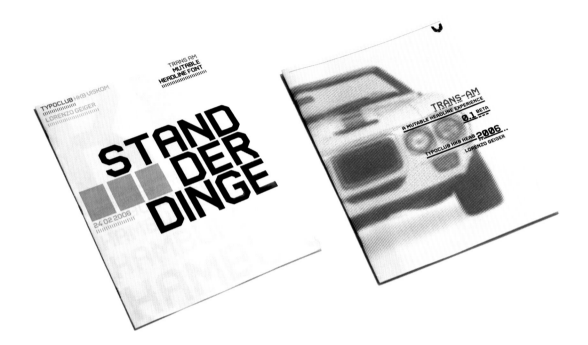

HELLO STRANGER! OPEN YOUR EYES AND LET ME INTRODUCE
THE VERY BRAND NEW MUTABLE HEADLINE FONT EXPERIENCE CALLED TRANS-AM: TYPOCLUB VISKOM JULY 07TH 2006 HKB HEAB

THE HEADLINE FONT CREATED TO GET SEXIER UNDERLINES FOR A BETTER COMMUNICATION

INCREDIBLE: A WAY TO CREATE HEADLINES AS NEVER SEEN BEFORE

ACCIDENTALLY GENERATED UNDERLINES

TYPE THAT WILL IMMEDIATELY CHANGE YOUR STYLE

START MAKING FONTPORN

GET THE EXPERIENCE. FORGET THE COMMON WAY TO CREATE UNDERLINES. ENHANCE YOUR SKILLS

AND DO IT WITH TRANS-AM

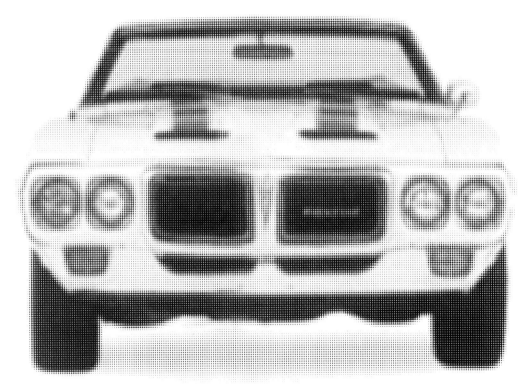

STAY TUNED; DONT MISS THE VERSION 0.1 BETA RELEASE ON JULY 7TH 2006 TYPOCLUB HKB

WHAT YOU SEE IS WHAT YOU WILL GET. AND THERE WILL EVEN BE MORE. HERE IS TRANS AM REGULAR

ABCDEFGHIJKLMNOPQRSTUVWXYZ
0123456789 ABCDEFGHIJKLMNOPQRSTUVWXYZ

HELLO STRANGER! OPEN YOUR EYES AND LET ME INTRODUCE
THE VERY BRAND NEW MUTABLE HEADLINE FONT EXPERIENCE CALLED TRANS-AM:

TYPOCLUB VISKOM JULY 07TH 2006 HKB HEAB

THE HEADLINE FONT CREATED TO GET SEXIER UNDERLINES FOR A BETTER COMMUNICATION

INCREDIBLE: A WAY TO CREATE HEADLINES AS NEVER SEEN BEFORE

ACCIDENTALLY GENERATED UNDERLINES

TYPE THAT WILL IMMEDIATELY CHANGE YOUR STYLE

START MAKING FONTPORN

GET THE EXPERIENCE. FORGET THE COMMON WAY TO CREATE UNDERLINES. ENHANCE YOUR SKILLS

AND DO IT WITH TRANS-AM

HEAD-

LINE-

PORNOSTARS

STAY TUNED: DONT MISS THE VERSION 0.1 BETA RELEASE ON JULY 7TH 2006 TYPOCLUB HKB
WHAT YOU SEE IS WHAT YOU WILL GET. AND THERE WILL EVEN BE MORE.

HERE IS TRANS AM REGULAR

ABCDEFGHIJKLMNOPQRSTUVWXYZ
0123456789 ABCDEFGHIJKLMNOPQRSTUVWXYZ

abcdeFghykLm

nopqrsTuuuuxYz

Concept

Trazo is a lowercase font, which, as its very name indicates (*trazo* means stroke in English), is represented as a continuous linear stroke linking the different letters. It has a predominantly curved design, which reinforces as well as softens this continuity. It is based on the handwriting of schoolchildren, who tend to write with clear, fully defined strokes. It has no numbers, and it only includes accents and underlining (to link words).

Contact info

Mondo Robot
Jerónimo Atienza Alcaide
mundorobot@gmail.com
Spain

La antigua academia

AMANECIDOS EN LAS ENTRAÑAS DE LA ISLA (SAN FERNANDO, CÁDIZ
CON VISTAS A LA AUTOPISTA, VUELVEN URSULA CON NUEVOS AIR
E INTENSOS QUE DE SINCEROS Y DIRECTOS. ESTRENAN SELLO (LE
MOMENTO, "AUTOAYUDA EMOCIONAL" NOS DA LAS PISTAS NECES/
EL CAMBIO NO HA SIDO EN BALDE, MÁS BIEN LO CONTRARIO: TO

URSULA

Tirando a dar

Texto_David Pareja / Foto_Samuel Sánchez

Ursula es hoy uno de los grupos más significativos del indie hecho en Andalucía: pertenecientes al ya mítico Colectivo Q, fueron pioneros en nuestro país en cuestiones de post-rock, realizando un pop de corte oscuro y pretensión experimental. Tras publicar sus dos primeros trabajos con Foehn, en 2001 y 2003, abandonan la casa que los vio dar sus primeros pasos de la mano de grupos hermanos como Balago. ¿Porqué

¿Los directos? Siempre son algo nuevo con respecto a la grabación, que es puro estudio y horas delante de la pantalla con instrumentos en las manos, excepto tus ojos... No se puede hacer en directo con tres personas. No seremos los mismos, además, hay gente nueva y enfocaremos las canciones a formato de trío de guitarras, bajo y ordenador. Pero ya sé vera, lo mismo se nos va la pinza y aparecemos

más dolier
gracias a D
por su va
a Arab Str
(inconfunc
ver a Coltr
que siguer
todas esta

HYMEN

la casa de los chicos malos

Texto_Vidal Romero

EN EL MUNDO DE LA ELECTRÓNICA EXPERIMENTAL, LOS SELLOS TIENDEN A BUSCAR UN LUGAR PROPIO, ALGO QUE LOS HAGA RECONOCIBLES, DIFERENTES A LOS DEMÁS. ESTÁN LOS QUE PROFESAN PASIÓN POR EL AMBIENT BONITO, LOS ADICTOS A LA IDM LABERÍNTICA, LOS QUE SE PIRRAN POR EL MINIMALISMO, LA INDIETRÓNICA O EL NEOCLASICISMO CON RUIDITOS, Y HASTA LOS QUE MEZCLAN UN POCO DE CADA. ESTÁ TODO ESO, SÍ. Y LUEGO ESTÁ HYMEN, QUE ES PUNTO Y APARTE. Y ES QUE EL SELLO ALEMÁN ES UN AUTÉNTICO HOGAR DE ACOGIDA PARA CHICOS MALOS: UN LUGAR DONDE LOS DISCOS ESTÁN REPLETOS DE ATMÓSFERAS ASFIXIANTES, RITMOS ENLOQUECIDOS Y SALVAJES, GARRULISMO PORQUE SÍ Y GRANDES DOSIS DE VIOLENCIA SONORA. DICHO DE OTRA MANERA: SI LO QUE LES MOLA EL TERROR EXTREMO, AQUÍ TIENEN SU SELLO.

La historia de Hymen comienza
ochenta. Stefan Alt, un joven
comunicación, había entrado er
electrónica a través de la Neu
new germany wave). Stefan r
días Kraftwerk todavía estaba
y que fue buscando alguna e
cuando tropezó "con un prog
pinchando un disco de Coil"
revelación, "me sentí anonac
escuchado algo tan extremo
comencé a investigar, fui de
bandas, y en poco tiempo m
imparable".

1. LA HORMIGA INDU
Con aquel virus comiendo p
hombre se enganchó a la ii
música industrial. "A finale:
muy a menudo, organizaba
hasta llegué a tener un clul
época buena y salvaje", cu
comenzó a tramarse en 19
concierto de Diamanda Gal
Stefan y su amigo A. Pickar
"en el que publicar la músi
invento se llamó Ant-Zen."
anti-zensur -anticensura-.
perfecta combinación entr
hormigas, dos cosas que m

ABCDEFGHIJKLMNOPQRSTUVWXYZ

abcdefghijklmnopqrstuvwxyz

1234567890?!*#@&([ɤ¶ℬℭℰ§)

≼Äêçñìò%≽/•→⇁;,

Concept

This font was developed for the book *DATA PILOT Sticker Collection: A flight over the external skin of communications*. It was inspired by a printer paper document with a very special combination of letters and figures and is exactly the look I wanted to achieve in this new alphabet. It stands for the processes used in the archaeology of communication.

Contact info

Designklinik
Björn Börris Peters
110@designklinik.de
www.designklinik.de
Germany

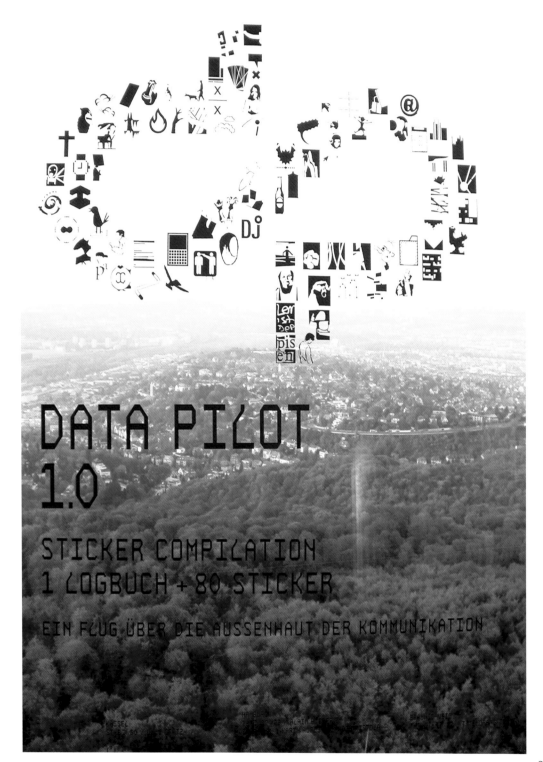

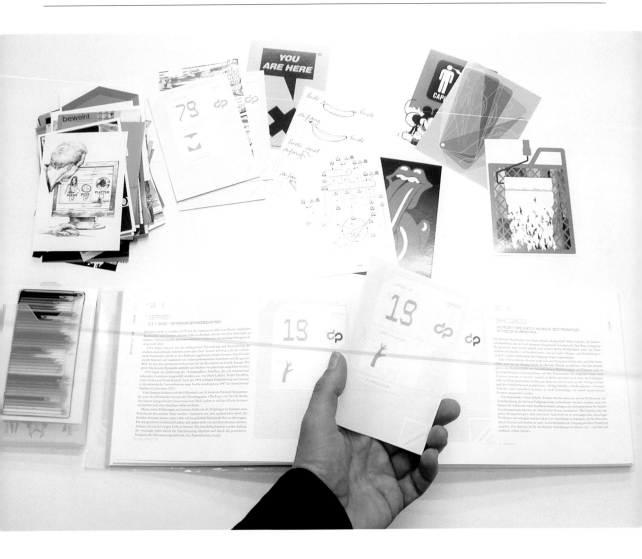

IMPORTANT: For best results from this material allow it to reach equilibrium with room temperature before using this Font.

≾ 110 ≿ WORK ORDER / TRIMATIC™ BBP

DK RELATIVE HUMIDITY AT 20°C: 50% ± 5% ⟨1.2.3⟩

FORMAT TYPE D≾+≿K: 58 x 34

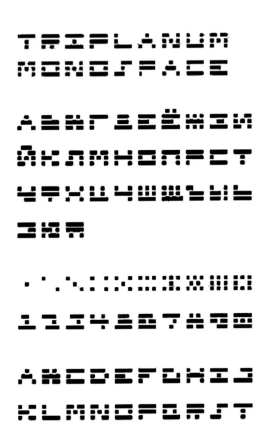

Concept

The characters in this font consist of horizontal levels and were made using a strong, easy three-level monospace system. There are two variations to the number set.

Contact info

ProDesign
Serge Pronin
sergey@prodesign.ru
www.prodesign.ru
Russia

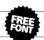

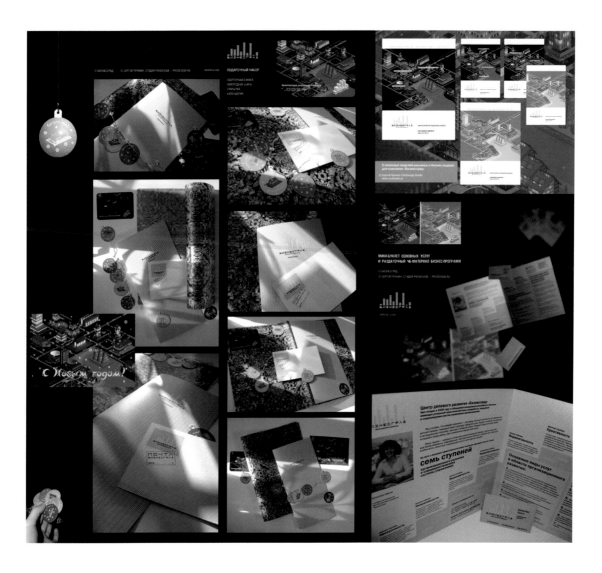

ABCDEFGHIJKLM
NOPQRSTUVWXYZ
1234567890
ÄÖÜ !?%./〈〉=

Concept

A friend of mine once brought an old agriculture magazine from the 1960s back with him from a trip to Thailand. The worn and battered logo for UNION AGROCHEMICALS in the ads in the magazine caught my eye, so I turned it into a font. It became an instant Polenimschaufenster classic!

Contact info

Polenimschaufenster
office@polenimschaufenster.com
www.polenimschaufenster.com
Austria

SUGARMAN, WONT YOU HAVE ME,
CAUSE IM TIRED OF THESE **SCENES,**
FOR THE BLUE COIN, WONT YOU BRING BACK,
ALL THOSE **COLOURS** TO MY DREAMS.

⟨SILVER MAGIC SHIPS, YOU CARRY...
JUMPERS, COKE, SWEET MARY JANE⟩

SUGARMAN, MET A FALSE FRIEND,
ON A LONELY DUSTY ROAD.
LOST MY HEART, WHEN I FOUND IT,
IT HAD TURNED TO **DEAD LAND COLD.**

⟨SILVER MAGIC SHIPS, YOU CARRY...
JUMPERS, COKE, SWEET MARY JANE⟩

SUGARMAN, YOURE THE ANSWER,
THAT MAKES MY **QUESTIONS** DISAPPEAR.
SUGARMAN, CAUSE IM WEARY,
OF THOSE **DOUBLE GAMES** I HEAR.
SUGARMAN, SUGARMAN!!

SUGARMAN // SIXTO RODRIGUEZ // 1972.

ABCDEFGHIJLMNOP
QRSTUVXZYWK

abcdefghijlmnopqrs
tuvxzywk

↖⌒◡! ? "" ,;: () $ •• @ ⌐+%⊃.ˈ

1234567890

Concept

The concept for this font is based on the street graffiti that originated back in the 1970s, though the specific letters are based on graffiti from the 1990s.

Contact info

Renan Moraes Guzzo
powerenan2@gmail.com
www.liquide.com.br
Brazil

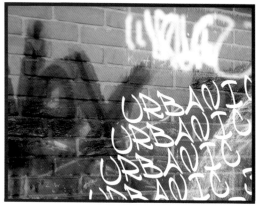

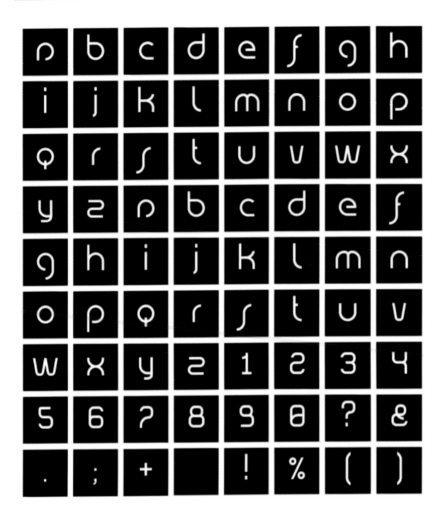

Concept

VegasOne was designed as a custom font during the rebranding of the Italian website Designaside. It is characterized by sinuous and supple lines and was developed using the circle as a starting figure. Its main features are its strong aesthetic impact and its good legibility. VegasOne can easily be used in visual identity and logo design projects.

Contact info

Designaside
Mauro Caramella
mauro@designaside.com
www.designaside.com
Italy

VegasOne

the quick brown fox jumps over a lazy dog.

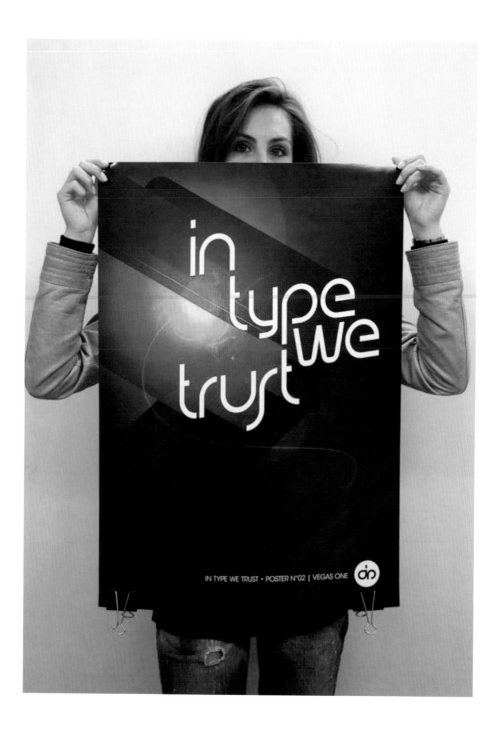

ABCDEFGHIJKLM
NOPQRSTUVWXYZ
abcdefghijklmn
opqrstuvwxyzÄöÜ
123456789.,!?-§$/

ABCDEFGHIJKLM
NOPQRSTUVWXY
abcdefghijklmn
opqrstuvwxyzÄöÜ
123456789.,!?-/

Concept

100% nature! This font was designed after real branches and leaves.

Contact info

Magma Brand Design (Volcano Type)
Sandra Augstein & Tanja Rastätter
www.magmabranddesign.de
www.volcano-type.de
Germany

aldi against aral

152153

F WALD ░ BLATT
WALD ░ AST
FRAKTENDON

you against me

ABCDEFGHIJKLM
NOPQRSTUVXYWZ

abcdefghijklm
nopqrstuvxywz

0123456789O

.:;><??"@

Concept:

This font was just an attempt to stir up conventional and bland Gothic-style typefaces like Arial and produce a bit of fresh air. Since 1998, it has been used for the titles and headings of *Design*, the design magazine of the UniverCidade School of Design.

Contact info

Henrique Pires
iav@univercidade.br
www.univercidade.edu/iav/rev_designe.htm
Brazil

Número 2 novembro de 2000

Baíta Sicupira Bruno Porto

Bugigangadrome Carlos Marcelo Paes

Carlos M. Horcades Eduardo Troia Flavio Pessoa

Gilberto Strunck Gunnlaugur SE Briem Gustavo S. Vianna

Henrique Pires Irmãos Campana João de Souza Leite João Galhardo

DESIGNE

João Lutz José Abramovitz Luís Eduardo Santa Maria Luiz Agner Caldas

Maria Isabella Muniz Milton Lando Myrna Nascimento

Núcleo de Ilustração Paulo C. Magno Richard Wilde

Rico Lins Roberto Caldas Romero Cavalcanti

Ruth Reis Typodrome Vanessa Duran

ESCOLA DE **UNIVER** INSTITUTO DE
ARTES **CIDADE** ARTES
VISUAIS VISUAIS - IAV

umentação: temos a história rico desses objetos?

[...]o, a história da

[...]ia, a história da arquitetura,

[...]arte, e

[...]história

[...]u a "his-

[...]etos tidos

[...]n dese-

[...]n do

[...]esse co-

[...]ndo de

[...]que vive-

[...]excesso

[...]ões que

[...]deia etc. e tal (aquela argu-

[...]ra manuais de identidade

va; que não serviam como notícia para jornais, que do mesmo modo não eram citadas no rádio, nem apareciam na TV;

signers de figurino e cenário tam[...] devem se ver em maus lençóis. [...] culdade de se conseguir docume[...] faz o passad[...] cer ter semp[...] jeitão de Casablanca.[...] feito intuitiv[...] confiando q[...] blico tambê[...] seja muito o[...] dor nem faç[...] exigência.

É consideráv[...] ta de inform[...]

Designer também tem SAUDADE

ou "Antes que nossa cultura inútil se apague"

por Henrique Pires Alves

que os mais jovens (mais jovens[...] nós mesmos) acabam tendo da [...]

typo drome

Typodrome é a seção da Desgine dedicada ao desenho e estudo das letras. Apresentamos a seguir alfabetos criados por ex-alunos, professores e amigos da Universidade. Se você cria tipos ou é um aficionado da tipologia passe no JAV. As Epatácio Pessoa, 1664 sl.203, ou envie um e-mail para typodrome@una.net e inscreva-se no Typodrome – Núcleo de Estudos em Tipologia da Universidade.

Why Not?, de Henrique Pires (professor da Universidade)

ABCDEFGHIJKLMNOPQRSTUVWXYZ
abcdefghijklmnopqrstuvwxyz
1234567890$@%?!;[^.~'~.)""

Hermann Stamp, de Luís Santa Maria (professor da Universidade)

ABCDEFGHIJKLMNOPQRSTUVWXYZ
ABCDEFGHIJKLMNOPQRSTUVWXYZ
1234567890 $&^+-=

Mobsletter, de Ricardo Maltz (ex-aluno da Universidade)

ABCDEFGHIJKLMNOPQRSTUVWXYZ
abcdefghijklmnopqrstuvwxyz
1234567890&£$°%?!;"" ("^`',)

Dico Light, de Walter Moraes Neto (ex-aluno da Universidade)

ABCDEFGHIJKLMNOPQRSTUVWXYZ
1234567890○ F?!!S[...]""

Zoo-Type, de Vanessa S. Duran (ex-aluna da Universidade)

ABCCDEFGHIJKLMN
OPQRSTUVWXYZ

Alfabeto criado para o Dicionário de Comunicação de Carlos Alberto Rabaça (professor da Universidade)[e] Gustavo Barbosa

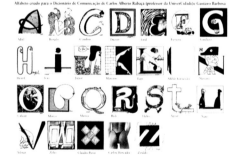

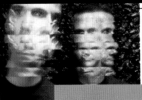

Designe: A gente ... uma ... na página de vocês na Internet. Você, Humberto, é advogado e ... nando, é arquiteto. O que vocês acham que vão estar fazendo no ano de 2010? Vocês estarão produzindo móveis nessa escala que vocês produzem hoje ou seguindo outros padrões?

Humberto: Estou olhando esse cartaz (aponta um cartaz de *2001 — Uma Odisséia no Espaço* afixado à parede) que foi o primeiro filme de ficção que meu pai me levou para assistir no Cinerama em São Paulo. Eu imaginei que no futuro iria estar voando, sozinho, sem precisar de equipamentos, e chegou 2001 e eu estou com o pé mais no chão e com um carro mais porcaria do que nunca (risos). Eu queria estar naquela nave ali (apontando outra vez para o cartaz), girando em volta da Terra.

Fernando: Eu, se pudesse prever alguma coisa, queria fazer uma cadeira – a materialização total do Design — fazer uma cadeira

para "viajar" ... se ... a gente vai alcan ... uma grande solu ... móveis dentro de u ... Gênio e solta, leva para praia, muda. Mudar ... temos nada em casa. As nossas casas, (somo ... mas não moramos juntos) são vazias, entende ... o que eu gosto, o que eu elejo como projeto. Eu moro perto do Pacaembu, que é um bairro dos anos 40, 50

ENtre a Criatividade e o Chicote

Entrevista com os Irmãos Campana

Desta vez, Designe entrevista uma dupla de designers que já alcançou sucesso internacional e é sinônimo de criatividade em design de móveis. Aqui eles falam sobre seu singular processo de criação a quatro mãos, de sua relação bem-sucedida com o mercado, inclusive a visão que, da Europa, se tem da criação feita cá abaixo do equador. Numa conversa descontraída com o pessoal da revista surgem tanto opiniões maduras, sobre a responsabilidade e o compromisso existencial de quem assume ser criador, quanto reve-

-lações do passado, do tempo de escola dos então estudantes que então definiam a vocação. Hoje reconhecidos inclusive por terem chegado ao Design via rotas diversas da formação tradicional, contam também o que esperam que o futuro da atividade de projeto lhes reserve. Entrevistando Humberto e Fernando Campana participaram, pelo IAV da UniverCidade: Luis Eduardo Santa Maria, Leonardo Visconti, Marcos Pires, Bruno Porto, Roberto Caldas, Carlos Horcades e João Lutz.

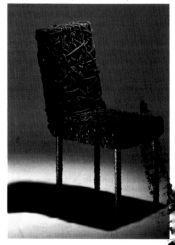

44

por Dulce Nascimento

Ilustradora botânica há 20 anos, premiada e reconhecida internacionalmente. No Brasil, ministra cursos para diversos grupos, inclusive para artistas estrangeiros.

ROTULARAM PEJORATIVAMENTE DE "ILUSTRAÇÃO" É CONSIDERADO EM TODO MUNDO ARTE PURA DO MAIS ALTO NÍVEL.

Algumas palavras sobre a ilustração botânica...

A ilustração científica é, em sua essência, uma forma peculiar de informação que transcende a tecnologia moderna. No passado, quando a linguagem ainda não existia, a ilustração serviu para

cavernas ainda hoje são instrumentos valiosos de estudos a respeito do modo de viver e de aspectos preciosos da evolução humana. Portanto, a importância do desenho enquanto meio de

ABCDEFGHIJKLMN
OPQRSTUVWXYZ
1234567890 .:;,...
%£@$€()&!?=+×
©◊ß∞®{}ÈÉÊËÑÇ
/<><>≈™*－－""'¿¡

Concept

This font came to me naturally one day when I was using the mouse to draw a poster in Illustrator. I had to put in a title and drew it in quickly to mark off the space. That was the start of this font. In the end, it looks like a linocut type and makes me think of the wooden letters at the entrance of ranches in Western movies.

Contact info

Johnny Bekaert
jb@johnnybekaert.be
www.johnnybekaert.be
Belgium

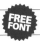

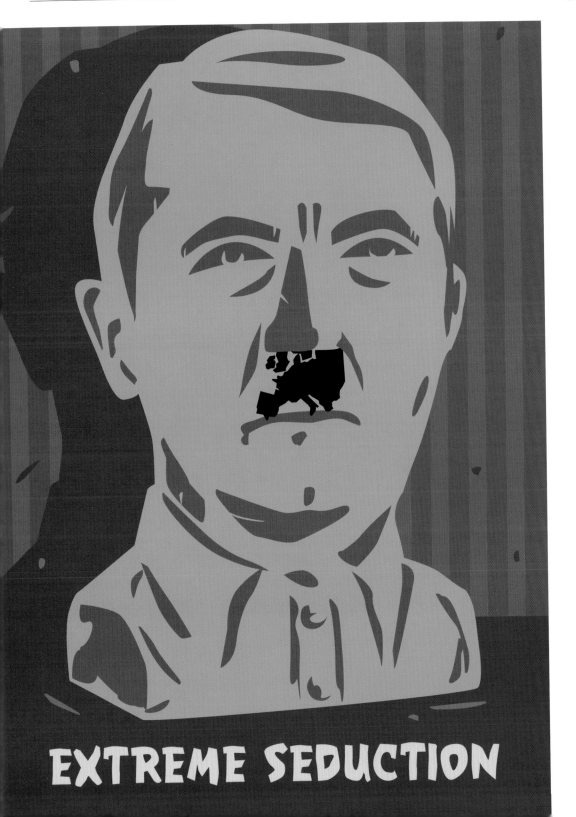

EVOLUTION THEORY

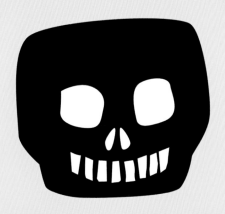

**SKULL – WESTERN EUROPE
ANNO 2155**

**SKULL – AFRICA
ANNO 2155**

**POESPÂ
PRODUCTIES**

KREA-LINE

343

Thanks a lot

Thank you to everyone who somehow helped me in the creation of this book: Adriana Jordan, Anibal Camera, Antoni Canal, Isabel Lorente, Neus Bas, Sylvie Estrada and all of the staff at Index Book. I would like to send out extra special thanks to all of the type designers, firms and students of mine who believed in this project.

See you soon!
Pedro Guitton

"My daddy told me when I was a young man
A lesson he learned, a long time ago.
You got to sing like you don't need the money,
Love like you'll never get hurt.
You got to dance like nobody's watchin'.
It's gotta come from the heart if you want it to work."

Don Williams

Directory